MW00649528

NEW ORLEANS
VOODOO

Rory O'Neill Schmitt, PhD & Rosary Hartel O'Neill, PhD

NEW ORLEANS
VOODOO

—A CULTURAL HISTORY—

Foreword by Vodou Priestess Sallie Ann Glassman

THE
History
PRESS

Published by The History Press

Charleston, SC

www.historypress.com

Copyright © 2019 by Rory O'Neill Schmitt, PhD, and Rosary Hartel O'Neill, PhD

All rights reserved

Front cover, clockwise from top left: The International Shrine of Marie Laveau; Sula Spirit, *photograph by Kim Welsh*; Drapo tapestry; potion oils at Voodoo Authentica; St. Louis Cathedral.

Back cover, from left: Vodou symbols in Rosalie Alley; altar in an Archade Meadows Voudou temple.

Photographs by Rory O'Neill Schmitt unless otherwise noted.

First published 2019

ISBN 9781467137997

Library of Congress Control Number: 2018959011

CONTENTS

FOREWORD

Hone. Respek.

Honor and respect. The first words spoken upon entering a Haitian Vodou temple. Honor and respect are offered to God—*Bondye* in the Kreyòl language—to the Lwa, the spirits of Vodou and the ancestors. Honor and respect are an essential part of service to the community of Spirit; to the elders; the priests, or oungan; and the priestesses, or manbo, to the human community and how one carries oneself. Vodou's early ancestors were enslaved in the New World. Everything was taken from them, including their dignity and their place and power in the world. It is no wonder that honor and respect became touchstones of healing and empowerment, through the grace of the Spirit.

Too often, journalists and filmmakers, writers and producers exploit salacious images of Vodou in order to titillate their intended audiences. The religion is presented as a depraved, orgiastic and evil practice. How refreshing, then, to come across Rory and Rosary's book. They recognized that Vodou is a deep, sophisticated practice and made the effort to educate themselves about the many forms the religion/tradition/culture has taken. They attended ceremonies; spoke with Vodou priests and priestesses, elders, practitioners, scholars and artists; and read scholarship on the subject. They explored the many paths of Vodou/Voodoo/Hoodoo/Voudon practiced in New Orleans.

FOREWORD

Because they are local New Orleanians themselves and have a love for their city, they want to present the local spiritual traditions from the perspective of natives: how Vodou permeates the life, history and culture of New Orleans. There is a reason New Orleans is different than any other city in the United States. Something only sensed unconsciously by many locals and visitors: New Orleans's soul beats to an Afro-Caribbean rhythm. As Rory and Rosary explore the many ways Vodou informs the practice of spirituality, how community forms and how artwork is created, the reader also is immersed in the journey.

While Rory and Rosary are outsiders to Vodou practice, it is said that it sometimes takes an outsider to truly see a practice with the alertness and attention that come with a new experience. Although I have studied and practiced and served as a manbo for many years, I am always learning. Vodou's waters run deep, and while based in tradition, Vodou is constantly changing, adapting, evolving. Each person interprets from her/his own perspective. It is wonderful to receive new information and insights from all the sources and practitioners presented in the book, as well as through the creative lens of Rosary and Rory's perceptions. Speaking of lenses, Rory's camera lens presents moments of mystery, expressed through movement and light.

Sensitivity, respect and tolerance form the bedrock of their approach and allow them entrée into the very private spiritualities of the practitioners presented. In the course of their research, Rosary and Rory have moved from outsider status to embrace core components of the religion, which they have integrated into their own personal spiritual practices. Vodou is an ancient spring of ongoing creative evolution and inspiration. Rory and Rosary are not anthropologists but creative artists themselves. They are speaking on themes they *know*, so their words and images resonate with authenticity and meaning.

Respect and honor to Rory and Rosary, to the ancestors and mysteries they present in these pages, to the extraordinary history they illuminate and to the ever-evolving and wondrous communities that emerge and contribute to the soul of New Orleans.

—Sallie Ann Glassman
Initiated Vodou priestess, artist, writer
and co-creator of the New Orleans Healing Center

ACKNOWLEDGEMENTS

So many champions have helped us in the glorious journey toward publication. We want to thank our brilliant editors, Adam Ferrell and Amanda Irle, for believing in us and in the value of Voodoo in our increasingly secular world. Our agent, Linda Langton, provided the needed enthusiasm and support behind the scenes.

Visionaries in the Voodoo community were helpful in illuminating research: Priestess Sallie Ann Glassman, Priestess Miriam Chamani, Priestess Brandi Kelly, Janet "Sula Spirit" Evans, Madame Cinnamon Black, Eugene Thomas and others. So many Voodoo practitioners, who wish to remain anonymous, provided essential interviews. Many holy ones, as well as individuals at the New Orleans Historic Voodoo Museum, were there in the background inspiring us. Scholars, as well as artists, including Dr. Martha Ward, Dr. Julye Bidmore, Dr. Stephen Wehmeyer and Adewalé Adenle, guided us to discover deeper meanings.

Colleagues at the New Orleans Writers Workshop provided numerous insights, and fearless writer and historian C.W. Cannon (who led the workshop) was tireless in his reviews and support. Assistants Laurie Sapakoff, Jim Bosjolie and Sara Frazier and photographers D.C. Larue, Kim Welsch and Traci Bower were wonderful resources.

We want to thank Heather Green and Leon Miller and the superb historians and librarians at the Historic New Orleans Collection and the Louisiana Research Center. They prepared carts of requested materials and had all of this knowledge ready. It was beautiful.

Finally, we wish to thank our families, particularly our mothers and grandmothers who have gone before us. We are grateful to our loving spouses, Robert Harzinski and Dasan Schmitt, and children, Dale O'Neill, Barret O'Brien, Rachelle Geerds, Olivia and Rowan Schmitt, who are ever-present blessings in our lives. Additionally, supportive and generous family members include Victoria and Brett Schmitt, Maya Schmitt and Jasmine Stevenson. Friends and loved ones inspired us to continue our work: Melinda Thomas, Monica Keyes, Allison Lee, Jennifer Weidinger, Joy Williams, Dawn Henry and Jackie Smith. Nina Kelly introduced us to important people in New Orleans.

One particular relative, Dick O'Neill, enabled this journey to happen. After inquiring about a chicken foot hanging from his rearview mirror, he introduced us to Voodoo and to his friend Sallie Ann Glassman. We remain so very grateful for this experience.

We embrace you, we cherish you and we thank you for giving us the strength to enter and learn about the magnificent world of Voodoo. May we all, through Voodoo and each other, grow closer to God.

INTRODUCTION

by Rosary O'Neill

Spirituality thrives in New Orleans. Everywhere there is a whisper—a secret that our ancestors exist and that religions, like Voodoo, know more than we do. I decided to study Voodoo because I was searching for God. I wanted to explore that life beside the mind that flourishes in Voodoo, which goes far back before the founding of New Orleans, and maybe through that observation become a holier person.

Through our search of Voodoo, I have come to ask: What if Voodoo is the gateway to the Divine?

My coauthor and I were born, raised and hope to die in New Orleans, our imperiled home. We (your authors) both grew up as New Orleans Catholics, went to Catholic schools, made our first communions and confirmations. Both of us had never experienced ancestral worship before nor a living embodiment of a spirit that was worshiped. The afterlife and the interior life were picked up from our parents and grandparents. As children, we knew little about Voodoo, and what we did was incorrect. Through our research, we have become able to see, understand and greatly respect Voodoo.

We had to do a lot of research because our degrees are in art and theater, and we weren't OK accepting just what we read at first or what we saw in life or on film. We didn't want to rely on anything that someone else had said to interpret how we felt about this religion. In being that way, we learned through the practitioners we met and experiences of Voodoo in New Orleans we had, and we gained a new insight into Voodoo. We're grateful that we had the proper time to live in New Orleans.

Introduction

There is an old saying: as a writer, one can write from the inside (the knower) or from the outside (the stranger). As daughters of New Orleans (insiders) and new explorers of Voodoo (outsiders), we invite you to come with us as we try to understand why this all-embracing religion captivates.

There is no more ghostly nor more spiritual city than New Orleans, a city that uses music, dancing, chanting and Voodoo to reach the Divine. Threatened by location, our ghostly city topples between a river, ocean and lake. Punished by weather, New Orleans is the rainiest city in America. This city has always been a holy city. Religious services, prayerful cemeteries, afterlife testimonials and celebrations for the dead permeate. For centuries, spirituality has been the pulsating heartbeat of New Orleans. So, let's hold hands as we jump off the cliff of realism into this mysterious world together.

RITES AND PRACTICES OF CONTEMPORARY NEW ORLEANS VOODOO

by Rory Schmitt

Before sharing what many contemporary Voodoo practitioners in New Orleans *do*, let's explore what several *believe*. Without meaning, there is no ritual. Inquiry often reverberates during investigation. Asking questions helps guide the process of understanding key components of New Orleans Voodoo as a religion.

IS VOODOO A POSITIVE BELIEF SYSTEM?

A monotheistic system, Voodoo centers on healing self, others and community. In Voodoo, practitioners see, feel and understand the Divine. They celebrate, venerate and respect Le Bon Dieu, the benevolent Spirit. No devil exists.

WHO ARE THE LWAS?

Lwas, who serve as intermediaries for God, are spirits syncretized as Catholic saints. In Louisiana's history, it was more acceptable for enslaved laborers to pray to St. Barbara, the patron saint of warriors, than to pray to Shango, the African Vodun god of war. Shango is the Orisha of thunder, lightning and justice, who instructs us how to "pull our power down from the heavens," says local priest Janet Evans.

In West African Voodoo traditions, Orishas are spirits who share likenesses with the Lwas. Janet Evans explains that the Orishas are guardian spirits who gently guide us to our highest destiny. In the Yoruba religious system, Orishas teach us about love, courage and integrity and remind us of our ancient lineage. An artist raised with Yoruba traditions in Nigeria told me there are so many Orishas that they are uncountable, like the gods and goddesses in Greek traditions.

Each Lwa likes certain items, colors, numbers, foods and drinks, and the offerings that practitioners provide respect the demigod's wishes. Though each Lwa can handle just about anything, each has a specialty and purpose. Local Voodoo priestess Brandi Kelley explains that each Lwa has a unique identity and history and likes to be honored in a specific way. Let's examine a few highlighted Lwas:

- OSHÚN: If you are expecting, you might pray to Oshún, who looks over pregnant women. Oshún is syncretized with Our Lady of Caridad del Cobre and Our Lady of Charity. You can offer her yellow flowers and candles, white wine, oranges or peacock feathers.
- EZILI LA FLAMBO: If you are a single mother, you might petition Ezili La Flambo with items in the colors of royal blue and red. Fierce, she offers protection and support to single mothers. During ceremony, she may run around with a dagger.
- ERZULI FREDA: For romance and love, you can call on Erzuli Freda and bring her offerings of perfume, lace and white wine. During ceremony, she is quite coquettish. She often wears a light pink or blue headscarf and carries a fan. She enjoys attention from males.
- OGO: For justice issues, you can petition Ogo, the metalsmith family of Lwas. As Ogo means "fire," these Lwas' preferred colors are fiery reds. While some Ogo are wilder and some are more distinguished, it's important to note that it is a family of spirits, and each has his own personality, preferred foods, liquor, colors and songs that must be prepared for each individual. Ogo are very militaristic, and during ceremony, they might march, click heels, speak boldly and loudly and yell orders to the congregation to get everyone in shape.
- MARASA: For the protection of children, petition the Marasa and share offerings of toys, black and white candles and salt

and pepper. They are twins who reflect the sacred duality of opposites and are syncretized with St. Damien and St. Comas. As they are the first children of God, they are the first to be honored at ceremonies. Though ancient, the Marasa twins present as childlike during ceremony. They enjoy eating candies, drinking sweet grape sodas and playfully running all around the temple.

• LEGBA: Before embarking on a journey, seek out Legba, who offers guidance at the crossroads. Legba is the source of communication between the visible, earthly world and the invisible, spirit realm. He is both a benevolent father figure, weary from traveling the world with his children, and a trickster. Often carrying a cane, he is syncretized with St. Lazarus, as well as St. Peter. Practitioners can offer him pipe tobacco, three pennies, bones, rum and Twinkies, Ding Dongs or other Hostess treats; the Lwas want to stay relevant with the changing times, after all!

WHO ARE VOODOO RELIGIOUS LEADERS?

Voodoo priests and priestesses are true leaders, advisors and visionaries in the New Orleans community. Ordained religious leaders in Voodoo include priests (referred to as oungans in Haitian Vodou) and priestesses (called manbos or mambos). However, no organizational hierarchy or gender-based leadership rules Voodoo, unlike the Catholic Church, where all-male leaders include the pope, cardinals, bishops and archbishops.

While Voodoo has ordained female clergy, no ordinations occur in New Orleans. Where clergy are initiated is determined by the type of religion they practice. West African Voodoo is different from Haitian Vodou, and clergy are initiated in places where they feel called. Voodoo centers abroad, such as Port-au-Prince, Haiti, and even as far away as the West African city of Porto-Novo, Benin, now confer ordinations, but in New Orleans, few know about this complex spiritual training.

The priestess's function is to guide people. She helps practitioners to mediate the spirit. She's not standing between that person and their relationship with Spirit. The distinction might be that in a Catholic church, the priest stands between the community and God and expresses God's word. In Voodoo, the priestess facilitates. But each practitioner's experience

is her own, and priest and practitioners all stand as equals with their own relationships with the ancestors.

In Voodoo, male and female Lwas are equally powerful. To see the spirit as male and female may be a paradigm shift for non-Voodoo practitioners. Equality between the genders is symbolic and perhaps transformational. It encourages respect of women and a tolerance for women in power. The Voodoo community often looks up to priestesses, who are viewed as loving, fearless and protective.

WHAT IS THE ROLE OF ANCESTORS?

When humans die, their spirits live on as ancestors, who offer protection and guidance to their living relatives and loved ones. Practitioners call out, evoke, invite and recognize their ancestors during ceremonies. Very real and present, they give advice to the living.

WHAT'S THE DIFFERENCE BETWEEN HOODOO AND VOODOO?

Common in rural parts of Louisiana, hoodoo includes individualized practices and rituals passed on through families. Ron Bodin, author of *Voodoo: Past and Present*, explains that hoodoo was developed out of necessity. Before the 1930s, no adequate roads, hospitals or doctors existed, and contact with the outside world was limited. Individuals, particularly those who were disenfranchised and oppressed, were drawn to hoodoo in Louisiana. Hoodoo provided a do-it-yourself religion in order to understand life and regain some semblance of control.

Spellwork and hexes characterize Louisiana hoodoo. Locals from all backgrounds may hire hoodoo practitioners for a variety of reasons: for health, protection, romance or to have elections with results in their favor. Local Vodou houngan Sen Moise explained Louisiana hoodoo and spellwork practices. He grew up with roots in hoodoo and southern conjure and is the owner of Crescent City Conjure in the French Quarter. He explained that southern conjure involves rituals to make a preferred change in your life. You create the conditions, such as fix oils, candles or incense, in order to *push* that change.

IS IT COMMON TO SEE DIFFERENT WAYS OF PRACTICING VOODOO?

According to Luisah Teish, a Voodoo priestess originally from New Orleans, New Orleans Voodoo is like the local spicy dish of jambalaya. Just as jambalaya involves many ingredients cooked together—shrimp, sausage, tomatoes, peppers and rice—New Orleans Voodoo blends the practices of three continents. Influential elements are: *African* ancestor reverence, *Native American* earth worship and *European* Christian occultism.

While your individual practice of Voodoo can connect to how you were raised, it can also be inspired by encounters with new spiritual traditions with which you resonate. Individual practitioners mold, combine and integrate traditions. For example, some local Voodoo practitioners weave in Judaism and the Qabalah into their practice, while others incorporate the Seven African Powers. Contemporary scholars identify Voodoo as a syncretic religion, which embraces other spiritual practices and adopts qualities of cultures it encounters.

Voodoo practices evolve over the generations. It is important to stress that there are several different forms of Voodoo. New Orleans Voodoo is different from Vodun, which is practiced in West Africa (called Juju in Nigeria), and Vodou, which is practiced in Haiti.

It may be surprising to learn that Voodoo is not restrictive. Voodoo whispers, *What does your heart feel connected to?* New initiates learn that you can be Catholic and Voodoo. Practicing Voodoo doesn't require you to abdicate any of your belief systems.

"YOU DON'T FIND VOODOO, VOODOO FINDS YOU"

While some New Orleanians may be born into families practicing Voodoo for generations, increasingly others join later in their lives. Voodoo is not just powerful; it is humbling. With humility, one must ask Spirit for help, clarity and acceptance. One local priestess shared that she respects Voodoo practitioners who have been practicing for twenty years and still feel like they can learn more.

Individuals practice Voodoo in both private and public realms. Legitimate reasons exist for why New Orleans Voodoo practices to this day are largely private. In its New Orleans history, Voodoo was prohibited from being openly practiced in public.

As Voodoo was forced to be a private religion, its practice became more of a solitary spiritual work consisting of sacred practices passed through the generations. Priestess Luisah Teish notes that since New Orleans Voodoo has been nurtured by a servant class with African roots, its practices became daily household acts.

Outsiders of Voodoo shudder when they hear *gris-gris*, as it was notoriously believed to inject harm. To understand gris-gris, one must learn about its roots in the herbal wisdom of indigenous tribes, as well as African peoples. Herbology for healing purposes dates back centuries in Louisiana. Dr. Martha Ward, an anthropologist and Marie Laveau scholar, explains that founders of Louisiana were dependent on native peoples for their deep knowledge of the land and their skills at using natural elements as medicine. African root doctors were Voodoo leaders who used natural herbs to heal diseases. To this day, Yoruba culture includes phenomenal herbology practices that bring healing with limited side effects.

Gris-gris comes from a Senegalese term and means "charm." Louisiana enslaved laborers sought African root doctors for gris-gris bags to gain special powers, heal diseases and ward off bad luck. A gris-gris bag strategically

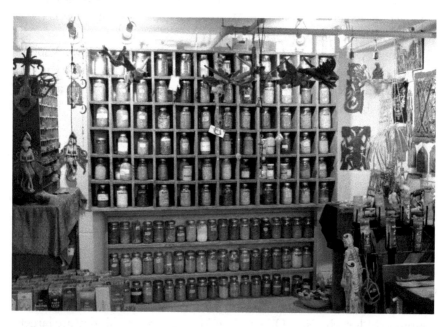

Herbology is a practice of many Vodou religious leaders. This wall features healing herbs at the Island of Salvation Botanica, which is located in the New Orleans Healing Center. *Photo by Rory O'Neill Schmitt.*

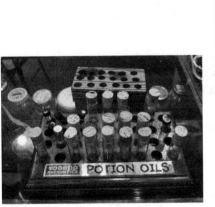

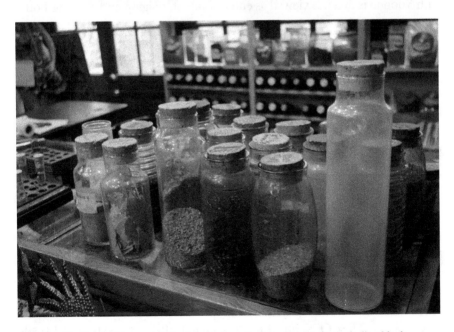

This page: Healing is the core of Voodoo. Potion oils, as well as herbs, including black cohosh root, chamomile and clove, can be found at the Voodoo Authentica store in the French Quarter. Additionally, individuals can purchase colorful candles for luck, protection and love. *Photos by Rory O'Neill Schmitt.*

placed could give some control over a situation. Gris-gris bags contain natural elements, such as dill seed, fennel seed, gingko leaf, chamomile, clover, black cohosh root, star anise, coltsfoot, althea, damiana and agrimony.

A positive charm, gris-gris supports and empowers. Voodoo priestesses share knowledge of how to apply the magical and medicinal powers of herbs. Local spiritual shops, like the Island of Salvation Botanica and Voodoo Authentica, sell herbs used for spiritual work and personal healing. For example, the mandrake root helps soothe the rift between Spirit and matter.

For many cultures, dreams hold significance in healing the psyche, as well as gaining deeper spiritual awareness. In Voodoo, dreams are vehicles for spirit communication. In our dreams, ancestors arrive as warriors protecting us with symbolic signs and gestures.

Like other religions, Voodoo practices have evolved over the years. Once acts done exclusively privately in the home or within small trusted groups of practitioners, they became ceremonies open to the public.

More and more people are drawn to learn about the authentic practices of Voodoo, and they travel from all over the world to find answers. A challenge with Voodoo is that it is viewed as entertainment, religion and a mix of both.

VODOU CEREMONY

In order to explain practices and rituals involved in New Orleans Voodoo, let's next journey to a Vodou ceremony in the Bywater neighborhood, near North Rampart Street. Woven throughout this narrative is a discovery process with information from literature, as well as interviews, which explain the associated history and symbolic meanings.

Entrance to the Temple

It's Saturday evening at sunset, and the Uber driver can't find the Archade Meadows temple in the Bywater. When I see Tibetan prayer flags and a metal statue of a man sporting a top hat, I realize, *This is it!* Next to a Rosalie Alley street sign rests Marie Laveau in a strikingly beautiful and raw graffiti mural. We're in the right place—physically and spiritually.

My father (Dick O'Neill), sister (Rachelle O'Brien Geerds) and I stroll down the narrow unpaved alley at sunset, admiring wooden fences with hand-painted crimson hearts, colorful skulls and dancing skeletons,

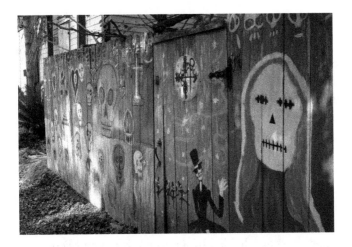

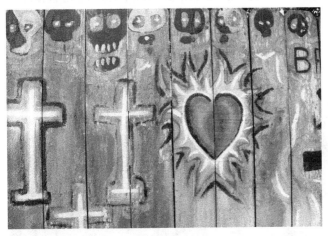

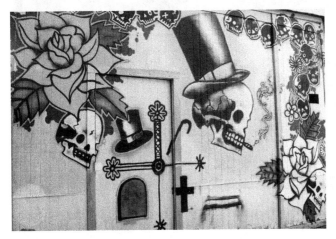

This page: Rosalie Alley is lined with wooden fences, displaying murals of smiling skeletons who often smoke cigarettes. One can also identify crosses, tombstones, vèvès and a heart in flames. *Photos by Rory O'Neill Schmitt.*

reminiscent of the Day of the Dead. Rachelle points out that underneath our skin, we are all the same.

At the end of the alley is a turquoise Louisiana one-story cottage flanked by giant palm trees. As I enter the Vodou temple, art swallows me. From the floor to the ceiling in salon style hang paintings, pictures, tapestries and flags containing images of skeletons, nature, Lwas, Haiti and New Orleans. Even from the roof, a neon octopus-like sculpture dangles. This house heralds art and nature.

Living altars wrap around the building's perimeter, containing a mixture of various textures, colors and sizes. I spot a framed photograph of a husky, unopened bottles of rum and a glowing Mary hurricane candle. The altars feel so personal. People left notes, beer and food—like you would for a friend. On one wall, two major altars are divided by a curtain. Rada and Petro are two energies that prefer to be separate:

- The Rada altar, adorned in light blues and pearls with a large central cross, invites cold and the element of water.
- The Petro altar, rich with hues of reds and maroons, embodies warmth and the element of fire.

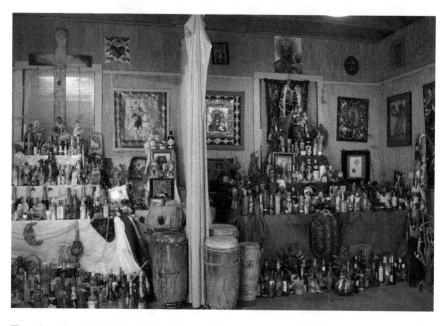

Two altars for the Rada and Petro, Lwas who prefer to be kept separate. Curtains divide the two spaces in this Vodou temple. *Photo by Rory O'Neill Schmitt.*

The Congregation

La Source Ancienne, a warm, positive and welcoming Vodou congregation, led by priestess Sallie Ann Glassman, welcomes us. She checks in with my family, as we are new guests, lovingly offering us chairs to sit on and saying it is okay if we don't want to dance or be possessed.

Before the ceremony starts, I introduce myself to one kind woman who is stretching. She tells me she is preparing for the ceremony, as much dancing is involved. Sometimes, she gets sore after dancing barefoot on the concrete floors. She says that her full-time job involves working full time at her computer. Voodoo practitioners defy any stereotypes of what they should look like or what careers they ought to have.

Later, when speaking with my sister, I learn that the practitioners do not look like what she had expected either. At this June ceremony, the community consists of about ten adults in their twenties, thirties and forties—white men and women, an African American woman, an Irish psychology PhD male student and an Australian female student filming her thesis. Rachelle noted that they looked so "normal." She even recognized one man (dressed in a white shirt and khaki shorts) from Whole Foods! Meeting Voodoo practitioners in their weekly practice shatters preconceptions. They aren't outsiders; they are soulful members of the New Orleans community, engaged humans practicing their spirituality.

That evening, congregants are dressed in purple headscarves and black, purple and white casual clothing, the preferred colors of the Lwa of honor that night: Gede La Flambo. A component of ritual is dress. For example, one ceremony calls for individuals to wear white and wrap their heads afterward.

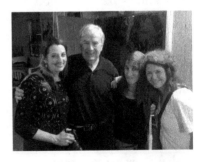

Rory Schmitt, Dick O'Neill, Sallie Ann Glassman and Rachelle Geerds are pictured here after a Saturday evening ceremony at the Archade Meadows temple. *Photo by Rachelle Geerds.*

Rituals

The priestess next opens all doors of the temple to let the natural light in. We are surrounded by nature at twilight. Inside, Christmas lights twinkle

and hurricane candles burn. I feel electric energy and connection with God. It is time to begin.

We stand in a circle around a wooden post, around which is a colorful painting of a winding serpent, as the priest and priestess co-lead the ceremony.

Dances

The priest, dressed in all white, begins the ceremony by picking up a machete and cutting crossroads into the air. He is the laplas, or master of ceremonies and apprentice under the presiding priestess. The machete is laplas's symbol, through which Spirit can enter.

Ritual art objects, such as drapos, are incorporated into the ceremony. Drapos are hand-sewn Haitian sequin tapestries that honor the Lwas. (Later, the priest's friend tells me that he sews drapos. The time it takes to create these sacred artworks defines it as a true practice of devotion.)

Practitioners carry large, gorgeous tapestries hung on poles and gracefully perform a choreographed dance. The priest flanks two drapo carriers and engages in a mock battle with the priestess. They bless the space and express gratitude.

Kreyòl Songs

Parts of the Vodou ceremony are spoken or sung in the Kreyòl language, which is the language spoken in Haiti. For example, to salute the Rada Lwas, we often responded, *Ayibobo*! According to Sallie Ann Glassman, Kreyòl was "born of the encounter between African dialects and the French spoken by colonists in Haiti." Enslaved Haitian laborers prayed in this language so that their captors couldn't understand them; Kreyòl was their language of freedom. Through Vodou ceremonies in Kreyòl, practitioners honor ancestors' struggles.

The priest guides us through the ceremony with a billowing voice and a ton of energy. He has been a member of the Voodoo community for over a decade. Each week, the congregation meets for choir practice. The priest's strong voice leads the congregants as we clap, sing, sway and dance around the central column. The temple becomes an almost hypnotic, spiritual space. At one point in the ceremony, sparklers are passed out and then lit to signify the arrival of a Petro Lwa. It feels celebratory. I watch as faces light up with glee around me.

Vèvès

The priestess, a brilliant ritualist, leads the congregation in prayers in English, French and Kreyòl. She honors our ancestors and invites spirits. Key to ceremony is the formation of *vèvès*, which are ritual drawings of Vodou symbols created on the floor out of cornmeal. These symbolic designs represent specific Lwas and serve as a focal point during the invocation. When creating the vèvès, Rachelle tells me she feels like the priestess is opening the gates to invite Spirit.

Imagine taking your fingers and adding a pinch of salt to your gumbo soup. In drawing vèvès, the priestess carefully pinches cornmeal and drops trickles to slowly form controlled patterns of lines with impeccable detail. Spirit guides the process. Pinching sand-like material from a heart-shaped glass bowl, she carefully creates golden straight, curving and flowing lines.

Each vèvè is unique and pertinent to a specific Lwa. For example, Gran Bwa is the Lwa who supports individuals connecting with their ancestors and Vodou. This Lwa's offerings include trees and branches, and his vèvè has human and tree-like elements. Oyá, often associated with destruction and storms, has a vèvè that includes a lightning bolt.

Connections prevail between vèvès and other world cultures. Each vèvè can be likened to a Chinese character or histograph, which is artfully made, holds centuries of cultural history and reflects deep meaning. Their impermanence also relates to Tibetan sand paintings, which Buddhist monks carefully craft into intricate designs and then gracefully sweep away. Additionally, viewing vèvès invites me to compare Navajos' spreading cornmeal carefully on the ground to create sand paintings on the floors of their hogans in Arizona.

Sometimes, individuals do not create visual art in order to be preserved and displayed. When making a vèvè, Spirit guides the priestess to write an image that holds deep meaning. After the ceremony, a practitioner sweeps up the cornmeal. Rather than being frozen in a frame behind glass, vèvès exist as ephemeral art forms that remind us life is always changing and the Divine guides us.

Honoring Gede La Flambo

Tonight's ceremony is dedicated to Gede La Flambo, the Lwa of sex, death and regeneration, who is syncretized with St. Gerard. Gede La Flambo is a fiery Lwa who can be provocative in his hip-grinding dances and his crass jokes.

Sometimes, there's a lascivious dance of trickster spirits that practitioners refer to. Gede is a trickster spirit who wears upside-down clothes, puts powder on his face and carries a cane that looks like a penis. He is meant to be funny. He takes possession of people. Everything changes—posture, walk, face, behavior. You don't recognize that person as this person. (I was warned it could get a bit bawdy.)

Sacrifices are specific offerings and symbolic gestures to the Lwas during rituals. The priestess instructs us to bring up our offerings to the center. We honor Gede with a wooden cross necklace, crosses, sunglasses with one lens, skeleton imagery, rum, hot peppers and flatbreads.

Possession

Possession is the experience of a particular Lwa entering a person's body and momentarily taking over. Proper training in preparation for this experience is important. It is recommended that congregants have been practicing Voodoo for a while before being open to the possession experience.

Voodoo practitioners call this being "ridden" like a horse. The horse (the practitioner being ridden) takes on a different stature, uses different body movements, speaks in a different tone of voice or grows in extraordinary strength. For example, one priestess shared that during ceremony, she witnessed an ordinary man pick up and spin a person over his head. The Lwa will let others know what he wants. Perhaps it's white *mouchoir de tête*, or headscarf.

During the ceremony that evening, the priestess blesses each person on the back with a rattle, an act that enables us to be open to spirits. She tells my family that we can decline if we want. (My father declines being open to possession.) Together, the congregation invites ancestors and spirits to enter from any space: from beneath the temple, through the open doors, from above. After the drumming begins, the spirits enter.

I witness three individuals experience possession. Spirit possession is not scary, like *The Exorcist* movie. It's subtle and natural. The first person to become possessed immediately becomes limp and is aided as she falls to the ground. As the Lwa, she is given libations. In this case, it is rum that Gede enjoys. The woman looks elated as she smiles and lies on the floor. I can't tell what she is saying because with the rest of the congregation, I continue to chant, sing and dance as we circle that central post. After about five minutes, the Lwa departs.

An ancestor named Madame LaCrotch next possesses a petite, sweet woman, and her body becomes totally transformed. Her voice becomes deeper; her facial muscles tighten up. She rests her elbow on a friend and becomes engaged in an entertaining and humorous conversation for half an hour. She throws back her head and drinks rum straight out of the bottle. She lights up and smokes a cigar and puts on dark sunglasses.

While we are dancing around the column, Gede enters the body of our priestess. It is a female version of the Lwa, who sultrily interacts with us for a few minutes. She grabs a black velvet top hat from Gede's altar and puts it on. She sways her hips and meows. The priestess returns to her own body, and soon after, we complete the ceremony.

Afterward, I speak with the woman who was dramatically possessed, but she lacks memory of the experience. She explains to me that if Lwas or ancestors want her to receive a particular message, they will tell a fellow congregant through her, and then this person can share the message. She explains that to be open to possession, you have to let go. You must release control. She also shares that the possession experience is part of her indigenous heritage. Her Native American ancestry from the southeastern region of the United States (present-day Alabama) has similar cultural practices.

Ancestors and spirits surrounding us during everyday life constantly support us. When people come together, they invite the possession experience as a way for Lwas and ancestors to communicate special messages.

The next day, the priestess shares with me more of her visions from the ceremony. She tells me that she saw the Haitian priest who initiated her. Her godfather, Papa Edgar, was smiling and beaming with pride. Nearby, his deceased brother, who was often involved in ceremonies, was there, as well.

CLOSING

Evolving from centuries of public and private rituals from multicultural origins, New Orleans Voodoo is a positive belief system that celebrates Spirit, Lwas and ancestors. Practicing Voodoo together builds strength, as the rituals are grounding, provide insight and offer support. Rituals are vehicles of devotion, enabling individuals to express gratitude and discover profound joy.

The next chapter shares challenges incurred due to misunderstandings of Voodoo. Fearlessly looking at stereotypes leads to the identification of rationales for these false narratives. Deconstructing fallacies builds a stronger presentation of Voodoo's truths.

MISCONCEPTIONS OF VOODOO

by Rosary O'Neill

Encountering Misunderstandings

When outsiders are drawn to study Voodoo, they are often seeking to find out how Voodoo brings practitioners closer to God. Additionally, they frequently try to understand why the religion is often misunderstood. This chapter explores misconceptions of the religion, as well as the historical reasons.

For instance, some may wonder, *Does Voodoo in any way defy God?* Sallie Ann Glassman, a white, Jewish, Ukrainian vegan woman from Maine, is a Vodou priestess in New Orleans. She says, "I think most people have a misconception that Vodou doesn't recognize God, but it does. All the intermediary ancestral spirits that are worked with in Vodou are an aspect of God's life force. It's a way to get a sense of the Divine, what sacred balance feels like and what is intended for health and empowerment in the world."

Glassman then characterized the practice in modern terms. "Vodou is a technology for opening that door to the spiritual realm, inviting it to come through, interact with us, inform and influence us. The invisible world is here to help us get through the physical world. And if you think about Vodou's early ancestors, they were slaves, and the physical world was pretty rough, and this ability to reach into a different reality, into a different source of power, beauty and dignity, helped them survive." Paradoxically, the spiritual solace Vodou provided the slaves caused slave owners to condemn it. As Glassman observed, "It sure freaked out the slave owners, and a conscientious effort was made to demonize the religion itself."

Former West African–initiated priest Eugene Thomas says that Voodoo was demonized because of fear and lack of understanding and also to disempower the enslaved. He said:

> *It was a source of power of sustenance, something they relied on. You know our ancestors came over there and they brought it over with them, and they relied upon what they remembered to survive to adapt. To disenfranchise them, whites said, "You have no culture. Your culture is meaningless." They used the Bible to curse the slaves as the children of Ham and verify their status. If you have no culture, no tradition, no knowledge of a past, if all you know is what you are being told, you are disempowered.*
>
> *And how were the enslaved to defend their religion? Voodoo has no scripture or world authority that believers could even refer to. There's no book, and there's nobody really in charge. Voodoo supports individual experience, empowerment and responsibility. Everybody has his or her own way of serving. Today, some practitioners have temples, some don't; some work alone, some work together. Everywhere Voodoo is practiced, it's a little different—in Africa, in the Americas and in Haiti. Because Voodoo was practiced by slaves in different Louisiana plantations, they were all isolated from one another. Everybody does it a little differently.*

Another practitioner commented on the freely expressive and individual nature of Voodoo spirituality. Practitioners sometimes perform ceremonies for one another, and they may not necessarily be initiated as priests. She said, "Ain't nobody got time for that, you know. If your particular blend of Voodoo works, it works, and nobody who comes to you and asks for something cares how you do it. Whatever ways you can find to contact [spirits], then that's what you find, and it's just as individual as the person doing it."

She also explained that Voodoo believers practice in the manner of several generations of Louisiana women. They often create and combine (or "mash it up") Catholic-like, African and Haitian aspects to create a personal religion.

Priestess Sallie Ann Glassman explained:

> *My involvement with Judaism is more on the mystical movements— kabala, a strain of which is incorporated into Voodoo—that we are part of what influenced Voodoo, and there are Jews in Haiti, and so neither one excludes the other. Most Voodoo practitioners are also something else. There is a phrase that Haiti is 80 percent Catholic and 100 percent Voodoo.*

Most people leave a discussion of God and heaven to Catholicism, in my case to Judaism. Our everyday life—what we are experiencing in relation to Spirit—is the realm of Voodoo.

Music in Louisiana Voodoo rituals is powerful, and therefore, it was historically criticized and oppressed. The music in ceremonies is prayerful. Eugene Thomas stated:

Why were whites so fearful of the drumming? It was from lack of understanding of what was being conveyed or shared. That is one of the reasons why the drumming was banned. It was being used in Brazil and other places where there were slave rebellions, and the organization of them was through the song and the dance and the hidden messages in the drumming…What came about was actually the banning of slaves from playing these particular instruments or being punished for doing it. It was a fear thing and a lack of understanding.

Hundreds of sacred songs and complex drum rhythms, which are used to connect with the divine, have been passed down orally in Voodoo. Today, Voodoo is still threaded through songs full of clapping, foot stomping and drum playing. One contemporary practitioner shared that he studied drumming for eight years to master the patterns.

Voodoo in New Orleans has empowered many women with agency in dire circumstances and led them to hold on to hope. Critics saw Voodoo liberate women who normally engaged in domestic work. They danced and chanted with a frightening inner power and took charge of their bodies and houses. Their spirituality threatened the status quo. By mocking their singing, shouting and dancing, critics could diffuse the joy and undermine the soulful basis of the practices.

Priestess Miriam Chamani explained how Voodoo drives motivation and resilience:

However you find God, it doesn't stop you from going out laboring. Every day, you go out and labor to make something sufficient for yourself and others that need you….No matter what has shaped you, it's you who are there. You don't look at what you've done, you look at how you are going to continue to rise up after the shaking. Voodoo is life. You breathe in life anywhere you go. In the beginning was the word, and the word was with God.

WHAT IS THE POSSESSION EXPERIENCE?

Religious ecstasy, an altered state of consciousness, is characterized by greatly reduced external awareness and expanded internal awareness. Visions and emotional (and sometimes physical) euphoria frequently accompany the experience. Although usually brief, sometimes it lasts days or more and reoccurs during one's lifetime.

A person's physical stature, human sensory or perception is completely detached from time and space. The "religious" part means that the experience occurs in connection with religious activities or is interpreted in the context of a religion.

In Voodoo, spirit possession happens during a religious ritual and is considered a sacred act. Such possession isn't so different from the ideology of the Holy Ghost or Spirit entering and taking possession of a Christian believer. Singing and prayer underpin both experiences, opening the channels for Spirit to inhabit the person. Trembling, convulsions and inarticulate vocalizations can occur, as well.

Body movements and vocalizations may conform to the rhythm of the music. The legs become heavy, while the rest of the body may seem to expand. Alfred Metraux writes, "People quake, stagger, make a few mechanical movements, and then, suddenly—there they are: in full trance." During the process of possession, the body is polarized between the head, where the Lwa enters, and the feet, legs and torso, which connect the possessed with the group and the earth.

Sallie Ann Glassman emphasizes how close the Vodou practitioner gets to Spirit, since spirits are the divine life force. The spirits come through your body; you don't have memory of what you experienced while possessed, but your body does. When Glassman comes out of that trance associated with this spiritual connection, there is a real sense of physical awe, and her "electromagnetic frequency has been changed, has been touched by something that is beyond the limitations of the strictly normal human."

Vodou film director and practitioner Olivia Wyatt says:

> There is an immediate shift in a person under possession. Facial expressions change. They speak in different accents, languages. People who only know Creole speak English with an Irish accent. Different spirits (or Lwas) may be there. Spirits are always being added to the pantheon because it's ancestor worship....There are hundreds of spirits: main family, main spirits within each family, the recent dead, the spirits of the graveyard. Things are seen

that can't be explained. Pouring hot pepper brew in the eyes. Because when people are "in spirit," nothing goes wrong. Spirits mount practitioners; that's how they worship and speak to their God directly.

In the United States, many people are afraid of spirits. They're afraid to go somewhere haunted. In Voodoo, individuals welcome the haunted because that is the worship. For practitioners, it's not considered a haunting. Possession is beautiful because it is a way you communicate with your God. In Voodoo, it's ecstatic for a minute, and then you go and have a regular conversation like we're having right now. You can talk to a spirit. Some people ask for advice if they are going through something traumatic.

Voodoo practitioners honor the possession trance experience. People who return from trances compare their experiences to the glow after great lovemaking, the knowledge of truth that comes in childbirth or the welcome visit from a beloved, long-dead relative in a dream. Practitioners want the spirits to stay for as long as possible, and there seem to be no similarities with demonic possession.

The possession experience can't be measured on the realistic plane, as it supersedes the scientific reality most Americans are comfortable with. Because this ecstatic state occurs so strangely and blooms and bursts upon the recipient, observers must necessarily be taken aback. But isn't that what most humans are yearning for: a deeper connection with Spirit? Many still fear possession on this side of the veil.

Hollywood Movies

Despite recent books and dissertations by Kodi Roberts, Carolyn Long and Ina Fandrich, most outsiders learn about Voodoo from Voodoo shops or horrifying caricatures from B-movies. Many demonizing Voodoo movies by Hollywood began with the American military's occupation of Haiti from 1915 to 1934. In 1929, the bestseller *Magic Island*, by W.B. Seabrook, introduced a cartoonish version of Voodoo into pop culture. An array of B-movies followed in the 1930s and 1940s. *White Zombie* (1932) frightens us with Bela Lugosi's signature spooky eyes and "mind control" zombies that murder the living. Reanimated cannibals in *I Walked with a Zombie* (1943) reinforce fears of the unknown.

B-movies soared with maniacal sorcerers, such as the one in *Voodoo Man*. Such horror movies promote cliché views of Voodoo practices with their

face paint, witch doctors, zombies and fetish dolls. *Live and Let Die* (1973) a James Bond film, shows a sadistic underworld. *Trilogy of Terror* (1975) horrifies with its Zuni fetish doll, which isn't Voodoo but a mix of migratory island religions.

Disturbing Hollywood images present Voodoo practices as something evil that can hurt us. Many blaxploitation films in the 1970s misrepresented Voodoo even further, using it as a counterforce against white racists. *Sugar Hill* (1974), a 200 percent revenge story, reveals zombies with glassy bug eyes and cobwebs, mindless servants doing their masters' bidding. *Tales from the Hood* (1995), a bloody film, shows dolls tearing apart a racist Klansman.

Even into the 1980s, mischaracterizations of Voodoo persisted. *Angel Heart* (1987) features a body-swapper having sex with his own underage daughter while blood drips from the ceiling. *The Serpent and the Rainbow*, a sensitive book about Vodou in modern Haiti, by Wade Davis, is recycled into a 1988 fright movie with every intolerant cliché: walking zombies, blood rites and ancient curses. *Skeleton Key* (2005) falsifies Voodoo with its exaggerated magic, evil curses and cursed African Americans. The Disney film *The Frog and the Princess* (2009) features a conniving Voodoo magician/villain who doesn't even merit the condescending exoticization afforded American Indian polytheism in *Pocahontas*. Lastly, *Voodoo Possession* (2014) presents practitioners as insane inmates. Ironically, while Voodoo practitioners were being pictured as hostile and violent carnivores, practitioners in New Orleans were helping to heal others with herbs, plants and natural substances.

The accusations about human sacrifice, cannibalism or devil worship are figments of fevered imaginations and a mean-spirited way to stereotype and turn Voodoo practitioners into the Other. Begun by slave owners and spiked by the B-movies originating in the 1930s, the "horrorization" continues today.

SNAKE DANCING AND ANIMAL SACRIFICE

Movie viewers may be leery of the snake dancing and animal murder that shows up in movies. In Haiti, the snake was a divinity, the serpent god, Dhamballa. When the spirit of the snake possesses Vodou priests, they don't speak; they hiss. In Haiti and later in New Orleans, practitioners used non-poisonous python snakes and performed dances that mimicked snake movements. But many snake rituals died out in the nineteenth century.

The only snake dancing Americans in any time have seen has been with the Appalachian Charismatics, who during worship use live poisonous snakes.

A snake dancer is pictured in this photograph, displayed at the New Orleans Historic Voodoo Museum. *Photo by Rory O'Neill Schmitt.*

Some New Orleans Voodoo practitioners don't believe in the divinity of snakes. A guide at the Historic Voodoo Museum (the only one of its kind in the United States; it claims to have Marie Laveau's prayer bench) noted that snakes can represent the devil. Meanwhile, another practitioner at the museum reassured others that snakes are wonderful. She has more than one python with which she dances. She likened her dancing to theater.

A few Voodoo practitioners do snake dances in New Orleans. Some might pay homage on certain dates, like Marie Laveau's birthday on September 10. Previously, many practitioners celebrated in the cemetery, but the rules have changed, as only licensed tour guides are permitted into many historical cemeteries.

A distinction between New Orleans Voodoo and other forms of Voodoo worldwide is animal sacrifice. Animal sacrifices don't readily occur in New Orleans ceremonies. In Haiti, a variety of animals, such as pigs, goats, chickens and bulls, may be sacrificed. The intent of this devotional sacrifice is the transfusion of the animal's life to the Lwa or spirit.

Former priest Eugene Thomas explained the ancient sanctity of animal sacrifice:

One criticism I hear of white Voodoo is that they don't do the blood sacrifice. How can you omit something that's vital to the culture and to the tradition? What is the blood sacrifice? You kill a chicken, you offer the blood, you pour the blood on the altar and basically you are offering a blood sacrifice. It's like when Christians take bread to symbolize the body of Christ and they take wine to symbolize the blood. A lot of white practitioners don't do that. They find that inhumane.

When I was a priest in New Orleans, we did blood offerings—a chicken, ram, goats, pigeons. After the animal dies, you clean it, cook it, eat it and share it among your people. It's not inhumane; it's more humane than going to the supermarket and buying a ten-pack of wings that have wings in there from you don't know how many birds that you have had no

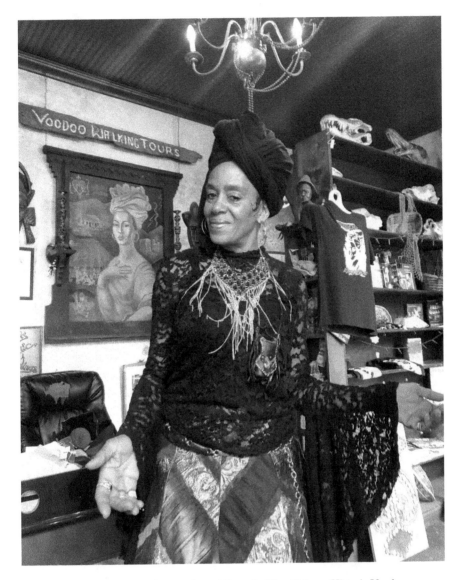

Madame Cinnamon Black educates the public at the New Orleans Historic Voodoo Museum. *Photo by Rosary Harzinski.*

touch with, no contact with. Some people get to hold the bird, you get to say prayers over it or to it or to a deity. It's an offering, and once everything is done, it's done with love and care and sincerity if it's done properly. The sacrifice is generally on special occasions. It can be done for an individual, it can be done for a group; it depends on the situation.

Voodoo for Sale

Because New Orleans is a very popular tourist city, and because Hollywood versions of Voodoo "sell," shops further distort the nature of Voodoo. If you live in the New Orleans French Quarter, you won't be able to walk five minutes without seeing "Voodoo for sale": sculptures with bold glassy eyes in store windows, tourist shops with spells, potions for the lovelorn, horse-drawn carriages with Voodoo tour guides shouting about trickery, cemetery tours, ghost tours, Marie Laveau tours.

On Chartres Street, St. Philip Street, Royal Street or any other street in the French Quarter, psychics, Voodoo and otherwise, decorate their tables with stones, bones, tarot cards and crystal balls. Signs hang from doors and storefronts announcing Voodoo readings within. The weary who come for consultations (mostly women) love hard and want to learn how to love harder and better. Even in crummy weather with icy breezes from the Mississippi, woebegone pilgrims inch up to Voodoo readers who sit scrunched by walls and over hooded tables. Offered for a fee, readings are also given over the phone, the Internet, in homes or at psychic establishments.

Tourists visit New Orleans for community, for love. (Wasn't the first piece of property that Marie Laveau owned on Love Street?) Many fear tourism will consume New Orleans Voodoo—a far cry from the animist, nature and spirit worship that were the essence of Voodoo's West African origins. Some say commercialization has harmed Voodoo already.

Miriam Chamani (born Mary Robin Adams in Jackson, Mississippi, in 1943) shared her perspective of locals and tourists intrigued by Voodoo. She is a mambo (mother/priestess) and co-founder of the New Orleans Voodoo Spiritual Temple, which focuses on traditional West African spiritual and herbal healing practices and sells dolls, beads, T-shirts and religious objects. She shared:

> *How do you classify Voodoo? If that's the one word we know about in the universe and it keeps us every day still struggling….People who cross my door keep running in saying: "What is Voodoo?" I have greater vision for my life than just one word. You can suffocate under that one word. Ain't nobody living on one word. I know New Orleans is bigger than that. It has crime and everything else and the black race of people suffocating and the young women across this city, and across the world, really.*

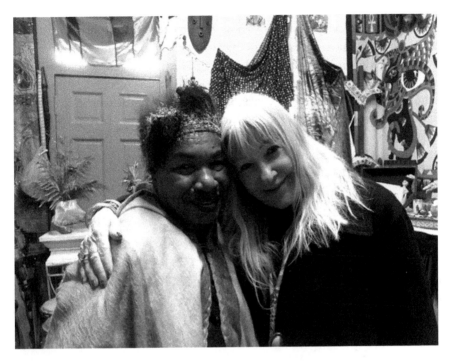

Rosary Harzinski and Priestess Miriam at the Voodoo Spiritual Temple. *Photo by Rosary Harzinski.*

Souvenirs blend Voodoo and hoodoo together even though hoodoo ware may not be linked to theology. Think a charm for luck, rabbit's feet, bags of earth and herbs (gris-gris), spell books, cleansing soap, magic oils and powders or Voodoo dolls, and you get an idea of hoodoo. The Voodoo doll (stereotyped as an object of horror) is just a symbol or charm mostly used for benevolent purposes. Some make the distinction: Hoodoo is magic or superstition; Voodoo is a religion, a method of reaching God. While harmless, Voodoo souvenirs distance buyers from the pursuit of "things holy" in Voodoo.

While sacred Voodoo practitioners may be quietly chanting or loudly praying, marketers are selling Voodoo as a costumed gothic music event. Two thousand musicians in sixty-five bands play the Voodoo Fest, a Halloween/rock/music weekend for one million folks in New Orleans.

New Orleanians are a visually interactive society, outside with our shops, parades and street singers (on almost every block in the Quarter) and inside with our videos, iPods, iPads, TVs and computers. To seek out the real meaning of Voodoo, individuals can experience the inner soul

in ceremonies. Few people may know how to access and participate in a Voodoo ritual, have a reading or have a consultation with a Voodoo or Vodou priestess in New Orleans. However, many can shop at a Voodoo store (real or electronic), watch a Voodoo film or listen to "Voodoo music." Dr. John and other contemporary jazz, blues and rock musicians rode in with fantastical "Voodoo" sounds in the early 1970s. But buyer beware. The real Voodoo is experienced privately before home altars and in gatherings where practitioners pray deeply. There are lots of holy women practicing Voodoo in Louisiana, and their numbers are growing.

Concluding Thoughts

This chapter uncovered misconceptions of Voodoo and aimed at clarifying essential meanings of this religion. Seeking to build a deeper understanding of New Orleans Voodoo, let's next explore the history of Voodoo in Louisiana.

THE ROOTS OF VOODOO: HAITI, WEST AFRICAN RELIGIONS AND CATHOLICISM

by Rosary O'Neill

HISTORY OF VOODOO

Why does such an ancient religion of ten-thousand-plus years appeal today? It is a religion having its roots in ancient Mesopotamia, Egypt, West Africa, India, Asia Minor (Turkey), Crete, Thessalonia, Israel, Greece and Rome, where women established their powerful temples and theocratic empires.

Voodoo is a fusion of religious practices from Africa that takes on different characteristics and emphases when practiced in various locations. Louisiana Voodoo has been heavily influenced by Roman Catholicism, as well as French, Spanish, Creole and American Indian populations who have lived in Louisiana. Voodoo is a deeply personal religion flexible, incorporating other religions, such as Catholic saints and rituals into worship, and is growing.

WHAT IS VOODOO?

Voodoo is a huge, dynamic religion deeply rooted in mystic practices already ancient before Christianity was beginning. Voodoo in New Orleans dates back to the spiritual folkways of West and Central Africans. Voodoo came to New Orleans in the early 1700s with enslaved Africans who were disenfranchised and who found ways to call upon a higher power to bolster their strength to survive. Through praying, many found a deep connection to God.

Thousands of Voodoo worshipers were sold into the West Indies. With them they carried a word, which was the name of their God. The word was *Vodu*, and soon, corrupted to Voodoo, it was an all-embracing term, which included the God and the sect but also all its rites and practices, its priests and priestesses and the people who obeyed its teachings.

The majority of African captives brought to and enslaved in New Orleans were Fon people from what is now Benin in West Africa. Their knowledge of herbs and the ritual creation of charms and amulets, intended to protect the self or harm others, became key elements of Louisiana Voodoo.

After the West Africans came the powerful French-speaking enslaved laborers from Haiti with their own Vodou rituals. Haitian practitioners believe that nothing and no event has a life of its own. The French term *vous deux*, which means "you two," connotes this belief. Each thing affects something else. Voodoo is an inseparable part of Haitian art, literature and music.

For centuries, Vodou was ferociously persecuted in Haiti. Atrocities were perpetrated against the followers of the Haitian people's religion, *sevi Lwa* (literally, the serving of the spirits of God).

Between 1791 and 1803, 1,300 Haitian refugees, a powerful seafaring group, arrived in New Orleans. Voodoo greatly expanded with their influx. These French-speaking immigrants adapted quickly to the French-speaking port, where even today a few locals speak French before English. Many people identifying as Creole (of French, Spanish and/or West African descent) in Louisiana still practice Voodoo.

A HIDDEN RELIGION

In the past, the practices of Voodoo remained hidden from the general public. Catholic churches (of which there are about 150 in New Orleans, which is now only 36 percent Catholic) don't embrace a large number of Voodoo practitioners. Most live isolated and unknown, except among a handful of friends. Maybe because the subject of Voodoo is quietly hidden, it intrigues millions.

Voodoo's practice of evoking ancestors may cause fear in non-believers. One New Orleans grandmother we met wouldn't allow the subject of death or discussion of Voodoo in the house. Believing death talk was contagious, she feared she might catch death from too much association with it.

Subjugation of Voodoo Practices

Slaveholders wrongly feared violence behind Voodoo. Gathering for Voodoo or any other rites in those early days was impossible.

According to a census of 1731–32, the ratio of enslaved Africans to European settlers was more than two to one. As a relatively small number of colonists were planters and slaveholders, the enslaved were held in large groups, which enabled their preservation of African indigenous practices and cultures. Except for a superficial conversion to Catholicism, the enslaved were not allowed to practice any religion at all. The Code Noir, originally passed by France's King Louis XIV, defined the conditions of slavery in the French colonial empire and restricted the activities of free people of color. Among the fifty-four articles effected in 1724 were: masters were to impart religious instruction to their enslaved; only the Roman Catholic religion was to be practiced; and intermarriage between Caucasians and African Americans was forbidden.

The Code Noir required religious instruction in the Catholic faith, though how regularly that occurred is hard to say. In the nineteenth century, enslaved peoples had opportunities to worship in Caucasian Catholic and Protestant churches, and planters sometimes hired preachers to come to their plantations. In these circumstances, preaching could attempt to indoctrinate the enslaved by espousing the virtues of submissive behavior and condemning rebellion.

At the same time, however, the gathering of the enslaved for any purpose could be very threatening to the enslaver, particularly after slave insurrections. The enslaved mostly had their own rituals in secret, where Voodoo was learned through word of mouth. They embraced Voodoo for communal enactments and special problem times, i.e., Voodoo prayers might be the only way to get a man out of prison. Like the roots of trees connected underground, Voodoo provided a net of connection and hope among the oppressed.

Many Voodoo practitioners (then and to this day) were afraid of how they would be treated, so they hid their religion. While this was understandable, it also reinforced suspicion that the enslaved practiced in secret to conceal something bad or violent. Fear begat fear. There was a growing concern among Caucasians that Voodoo meetings were to effect magic against them, if not to plot an eventual revolution. On the plantations, the enslaved got together to dance and worship outside their tiny field cabins away from the big house, but the enslaved in New Orleans lived closer together. Habitation

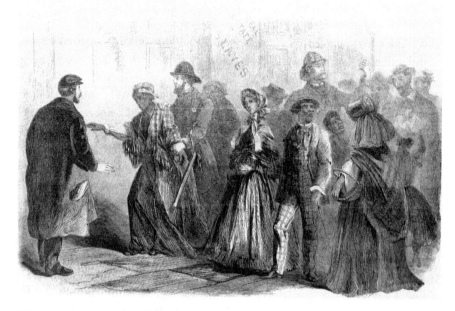

This wood engraving is titled *Revival of the Old Slave Laws of Louisiana—A Scene in New Orleans—The Arrest of Contrabands on the Night of January 30, 1863.* Courtesy of the Library of Congress.

spaces for the enslaved were to the rear of urban dwellings. In New Orleans' Vieux Carré, the two-story service buildings housed any number of functions, such as kitchens and washrooms on the first floor with living space for the enslaved, servants or young men of the household above.

Voodoo Ceremonies in Congo Square and Lake Pontchartrain

An abandoned brickyard on Dumaine Street in the French Quarter is purported to have been the first Voodoo gathering place, from which the police soon drove the worshipers. For this reason, the city issued a municipal ordinance in 1817 that forbade the gathering of the enslaved for dancing or any other purpose except on Sundays, and then only in places designated by the mayor. Congo Square, located on North Rampart Street in the heart of the city (presently the site of Armstrong Park), remained one such designated area. Here were held Voodoo dances, the ones that were frequently observed by Caucasian society.

In Congo Square, some women would become possessed with the spirit, dancing with snakes. A snake in Christian religion represents Satan, not a divine spirit, as it does in Voodoo. Public expressions of Voodoo also intrigued Caucasian women, who wanted to break free from their oppressed household status and express themselves.

More authentic Voodoo rites were conducted in secret farther from the city, along the shores of Lake Pontchartrain and Bayou St. John. Here, the bonfires blazed and the drums took up their beat. The current Voodoo queen was always present, of course, the most elaborately dressed woman and the most carefree. For the Voodoo queen was never a slave but always a free woman of color who need fear no curfew nor any of the laws applied to the enslaved. They did sing Voodoo songs, but most of these, the Caucasian public could not understand—even when they were mocking them, like the Calinda dance originating from African stick fights.

French Creole:
Mo té ain négresse,
Pli belle que Métresse.
Mo té vole belle-belle
Dans l'armoire Mamzelle.

English Translation:
I was a Negress,
More beautiful than my mistress.
I used to steal pretty things
From Mamzelle's armoir.

Dansé Calinda, Bou-doum Bou-doum, Dansé Calinda, Bou-doum Bou-doum,
Dansé Calinda, Bou-doum Bou-doum! Dansé Calinda, Bou-doum Bou-doum!
[Bou-doum Bou-doum was a sound meaning to fall down.]

Many versions of ceremonies contain a snake, a sacrifice and a bowl of blood. In the original African rite, the priestess lifted a python from the box and allowed it to lick her cheek. From this touch, she received vision and power and became an oracle. According to one Dahomeyan legend, the first man and woman came into the world blind, and it was the serpent that bestowed sight upon the human race.

VOODOO'S CONNECTIONS TO CATHOLICISM

Early nineteenth-century New Orleanians spoke French and were vibrantly religious and singularly Catholic. As a result of the fusion of Francophone culture and Voodoo in Louisiana, Haitians and Africans associated many Voodoo spirits with the Christian saints known to preside over the same domain. Both Catholicism and Voodoo had a mystical base. Voodoo practitioners had a yearning to celebrate and contact their God, and many did so through ecstatic experience. Many Catholics also believed in mystical experiences. For example, it is said Saint Theresa of Avila levitated when praying so much that the nuns had to hold her down. And the apostles at Pentecost had the gift of tongues—speaking ecstatically in many languages.

Although some doctrinaire leaders of each tradition believe Voodoo and Catholic practices are in conflict, in popular culture, both saints and spirits are believed to act as mediators, with the Catholic or Voodoo religious leaders presiding over specific respective activities. Vodou has ordained clergy, oungan (priests) and manbo (priestesses) that make a commitment to a spiritual path and can offer guidance when needed. Early followers of Voodoo in the United States adopted the image of the Catholic saints to represent their spirits.

The supreme being common to most indigenous African belief systems was analogous to God the Father, and the deities and ancestors who serve as intermediaries between men and the supreme being became identified with Mary the Blessed Mother and the legion of saints. Other Catholic practices adopted into Louisiana Voodoo include reciting the Hail Mary and the Lord's Prayer. The rituals, music, vestments and miracle-working objects of the Catholic Church seemed intrinsically familiar to Africans, whose religious ceremonies stressed chanting, drumming, dance, elaborate costumes and the use of spirit-embodying charms. Through a process of creative borrowing and adaptation, practitioners reinterpreted Roman Catholicism to suit their own needs, moving easily between the two as the occasion required.

Many people's lives revolved around family and the Catholic Church, especially the St. Louis Cathedral, the center of religious life in the Quarter. The oldest continuously active Roman Catholic cathedral in the United States, St. Louis opened its doors in the French Quarter in 1727.

Indicative of the happy coexistence of Catholicism and Voodoo, the legendary Voodoo queen Marie Laveau attended Mass at St. Louis Cathedral and was buried in St. Louis Cemetery No. 1. Catholic influence

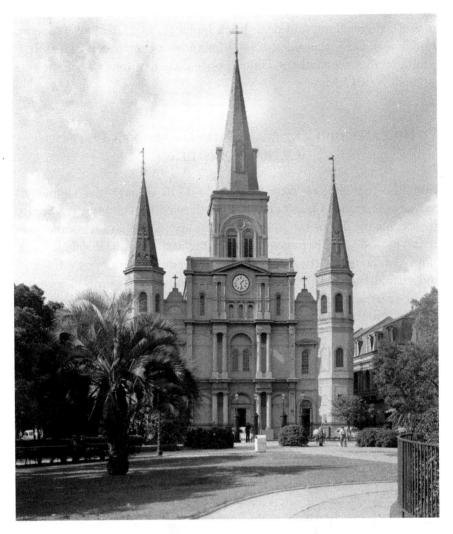

This photograph, which depicts the St. Louis Cathedral, was created by Frances Benjamin Johnston in the 1930s. *Courtesy of the Library of Congress.*

can easily be seen in the French Quarter, where many streets were named after saints: St. Philip, St. Peter and St. Louis. (Marie Laveau lived on St. Ann Street.)

There are many other churches on back streets. But still, on the thoroughfares, one has a feeling that God and Catholicism are everywhere. So many gorgeous Catholic schools were constructed in nineteenth-century New Orleans (which is the second-oldest diocese in America),

as well as block-long and deep brick buildings like Ursuline Academy, founded in 1727, the oldest school for girls in the United States. It is estimated that the Catholic Church once owned 50 percent of the real estate in New Orleans.

NINETEENTH-CENTURY SPIRITUALITY IN NEW ORLEANS: CATHOLIC INFLUENCE

From the founding of New Orleans in 1718 through the eighteenth century, the French Quarter constituted the city in its entirety. As the city grew dramatically in the nineteenth century, the Quarter became one of the most densely populated areas in the entire South. Residents were mostly of French, African or Spanish descent, joined later by Italians, and virtually all were Roman Catholic. People lived crowded together by the river and sought ways to free themselves from the desolation of sickness and death.

Above and opposite: These historical photographs capture life in New Orleans neighborhoods ages ago. The beautiful architecture provides balconies where people might step out for fresh air. In the 1920s photograph by Arnold Genthe, an organ grinder shows how music is engrained in the city's culture, often found in street performances. In this picture, notice the foreground, which includes tracks, probably from the streetcar line. A 1900 photograph by the Detroit Publishing Company shows Jackson Square. One notices the statue of General Andrew Jackson, who defeated the British at the Battle of New Orleans during the War of 1812. *Photos courtesy of the Library of Congress.*

Fear of Death

People prayed and begged God to be spared. Hopelessness was only assuaged by leaning on God. On Sundays during hurricane season, thousands of locals flocked to Ursuline Convent to pray to Our Lady of Prompt Succor to save them once more from another disaster, as she did from fire in 1788 and from invasion by the British in 1815.

Death and life lived side by side in nineteenth-century New Orleans: cemeteries and churches; ballrooms and convents; dance halls and monasteries. The shadow of death intensified everyone's spirituality.

Many diseases plagued this seafaring city in the nineteenth century: malaria, yellow fever, scarlet fever, flu and tuberculosis. Diseases were carried far and wide by rail and boat, and the city also attracted hurricanes.

Little crosses engulfed Catholic cemeteries. The infant mortality rate was 28 percent. One out of eight women died in childbirth. Having numerous children enhanced a family's church and social status, and most families abided by the church's tenets with regard to children. Most women died before forty-nine. Life was a third shorter back then. The average woman had seven children. Bearing this many children in a time of questionable nutrition and medical care gave women a lower life expectancy than men.

Graveyards were part of life. St. Louis Cemetery No. 1 was the main burial ground, but two more Roman Catholic cemeteries (St. Louis No. 2 and St. Louis No. 3) were also constructed. Aboveground vaults predominated (because of New Orleans' high water table, graves weren't dug "six feet under"), and stone tomb houses flaunted statuary. Mournful statues were dramatic and a constant reminder of death—small children pulling at a mourner's skirt, kneeling angels, ascending angels and Christ resurrected.

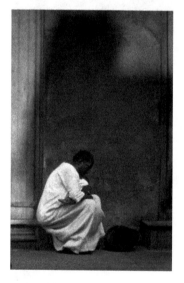

This 1920s photograph by Arnold Genthe, called *A Lullaby, New Orleans*, shows a woman cradling an infant. *Courtesy of the Library of Congress.*

In the 1920s, Arnold Genthe (1869–1942) created these photographs depicting St. Louis Cemetery in New Orleans. The cemetery contains aboveground vaults. *Courtesy of the Library of Congress.*

A CATHOLIC CLOSED CIRCLE

Catholic New Orleanians committed their education and socialization to Catholic institutions and people. For example, Catholics weren't allowed to visit non-Catholic churches. Catholics dated Catholics, and "marrying outside the church" was considered an outrage. For Catholics, all other religions were held in suspicion. Most Catholics had never been inside a Protestant church. The Church condemned any form of fortunetelling or occult practices, such as tarot cards and psychic readings.

WOMEN IN VOODOO

Still, the practice of Voodoo gave many people, women in particular, hope. In Voodoo, there is a great respect for women and elders. Voodoo is primarily a matriarchy. Men sell herbs and participate in medicinal practices, but

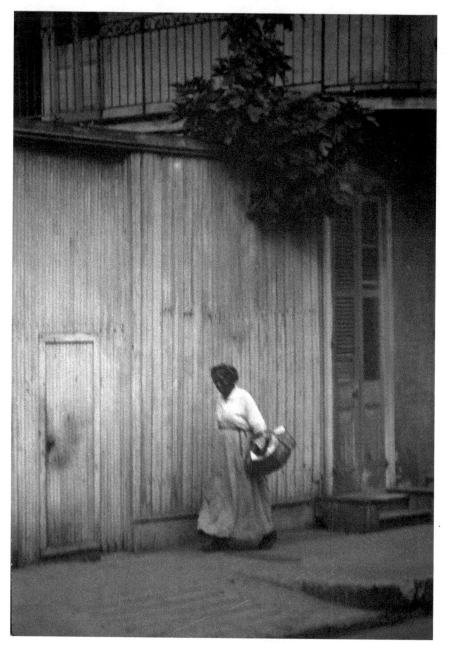

This photograph by Arnold Genthe, *Going to Market, New Orleans*, shows the photographer's soft focus, Pictorialist style. *Courtesy of the Library of Congress.*

women often run the rituals and services. These holy women were often blessed (and still are today) with visions and the gift of prophecy.

In the nineteenth century, while many Catholic women didn't go out unescorted, free women of color and Voodoo priestesses visited hospitals, prisons and death rooms alone, where many languished in despair. Because of Napoleonic law, women shared the ownership of their husbands' property. Many free women of color owned their own houses.

Summary

Voodoo offered its practitioners of African descent a way of maintaining a cultural tradition encouraging the infusion of new religion with the wisdom of centuries. Serving as a means of communication and empowerment, Voodoo championed the voiceless: women, African Americans, immigrants. All inclusive, it provided a common bond for communication and worship. Because it was private, Voodoo protected the practitioner from intrusiveness and assault and helped heal the loneliness and isolation many felt in a new country where lawlessness, crime and sickness were rampant. While New Orleans leadership changed from the French to the Spanish and then to the Americans, Voodoo remained. Then and now, its adaptability allowed individuals to contact the Divine in myriad ways. Founded in a deep spirituality and secret and public prayer, Voodoo inspired its followers to connect with a higher spiritual plane.

Chapter 4 will present the most famous New Orleans Voodoo queen, Marie Laveau. Through Voodoo, Marie showed how this spiritual practice gives strength to face brutality, isolation, subjugation, misunderstanding, misery, disease, loss and death.

MARIE, MATRIARCHY AND MOTHERHOOD

by Rosary O'Neill

MARIE LAVEAU, WOMAN LEADER

In the nineteenth century, Voodoo Queen Marie Laveau ran a religious matriarchy healing the sick and sorrowful and birthed nine children. In a time when women feared going out, Marie Laveau walked the streets. In a time when women didn't work, she became an entrepreneur. In a time when dancing in public was vilified, Marie openly set up events in Congo Square.

So great was her impact that the name Marie Laveau has resonated throughout New Orleans for two hundred years. Much of Marie's life was mysterious because she and many of her colleagues didn't write. So much confusion prevailed that people don't know if there were one or two Marie Laveaus, with her first daughter assuming her robes when her mother died. We do know Marie Laveau the First triumphed in New Orleans.

BIRTH AND CHILDHOOD

Here are the facts: The first of her maternal line to be born free, Marie Laveau thrived on independence. In 1743, her great-grandmother Marguerite was transported at the age of seven from Senegal to Louisiana aboard the last French slave-trading vessel. Having been enslaved, Marguerite had no surname. Marguerite and her daughter, Catherine (Marie's grandmother), were held in slavery. After a long procession of different owners, Catherine was finally emancipated by her last one. A few years prior, in 1790, her

The Pontalba Apartments, which flank Jackson Square, are known for their balconies' lace ironwork. In the background, notice St. Louis Cathedral, the church where Marie Laveau attended weekly Mass. *Courtesy of the Library of Congress.*

daughter, Marguerite Henry, had been freed by her owner (possibly also her father). Marguerite had a brief relationship with Charles Laveaux (originally spelled with an "x"), a successful mulatto businessman, and Marie Laveau resulted from this union.

Marie Catherine Laveau (1801–1881) was born free in the French Quarter of New Orleans, the natural daughter of Marguerite Henry, a free woman of color of Native American, African and French descent, and Charles Laveau, a free man of color of African and French descent. Although legally married to someone else, Charles recognized his daughter and gave her property.

Marie Laveau was Creole, a term that French settlers originally used to distinguish Louisiana natives. Creoles share cultural ties, such as the French language (Marie spoke French) and the practice of Catholicism.

Like many Creoles, Marie was baptized, christened and attended Catholic services in New Orleans all her life. Scholars, like Dr. Carolyn Morrow Long, have further explored listings in St. Louis Cemetery, where Marie and her family are buried, and the sites where she practiced Voodoo: Congo Square, St. Ann Street and Lake Pontchartrain.

PLAÇAGE AND MARRIAGE

Marie didn't grow up a free person of color unscathed. Her childhood was weighted by institutionalized racism. It was painful being African American in a town that gave social privilege to people based on their gradations of white: octoroon, one-eighth white; quadroon, one-quarter white; mulatto, part white.

The society upheld a system called *plaçage*, an extralegal system in French and Spanish slave colonies of North America by which ethnic European men entered into the equivalent of common-law marriages with non-Europeans of African, Native American and mixed-race descent. The term *plaçage* comes from the French *placer*, meaning "to place with." The women were not legally recognized as wives but identified as *placées*; their relationships were seen among the free people of color as *marriages de la main gauche*, or left-handed marriages. The arrangements became institutionalized with contracts and negotiations that settled property with the women and their children.

The system flourished in New Orleans, where African American women were placed with white men at Quadroon Balls. The appalling custom held that if a woman was darker than a piece of light tan paper kept at the entrance, she was rejected. Many mothers felt the best they could do was "place" their daughters with a white man in a house he bought for them and their children. African Americans were legally forbidden to marry whites and could be jailed if they did.

But Marie didn't get very caught up in the tradition of "you grow up, you get 'placed.'" She had an independent streak and would receive property from her well-to-do father, who traded in real estate and slaves and also owned several businesses.

Exquisitely beautiful, she fell in love with Jacques Paris when she was fifteen years old. Jacques was a French Creole man who found refuge from Haiti in New Orleans. Then, she married him in the Catholic Church. Pregnant, she began planning a future with him.

ENDANGERED CHILDBIRTH, EPIDEMICS AND MEDICAL CARE

Childbirth Dangers

Back then, childbearing was extraordinarily dangerous. African American women might lose 40 percent of children in childbirth and another 19 percent to breathing problems, accidents and infectious diseases. Comparatively, for

the average woman worldwide between 1850 and 1900, infant mortality was 25 to 30 percent.

On average, women gave birth to six children, not including miscarriages and stillbirths; many had complications, such as lacerations and permanent damage to their organs and bodies, childbed fever, hemorrhage or dangerously high blood pressure. The practice of obstetrics was disparaged because of the flagrant intimacy it demanded of male doctors, it being seen as a horror that men should study the vagina or reach up into the birth canal. Most working-class women didn't have the opportunity to see a doctor or to rest and recover.

Epidemics

The most deadly diseases to strike Louisiana during the antebellum years (1812–62) were cholera, smallpox, malaria and yellow fever. Victims died horribly, discharging watery diarrhea or vomiting uncontrollably (cholera); bodies swelling with raised, fluid-filled red blisters (smallpox); bodies writhing from shaking chills, muscle spasms, diarrhea or vomiting (malaria); or skin turning yellow from clogged urine and black vomit (yellow fever).

Death rates soared highest in urban areas like New Orleans, where large numbers of people packed into small areas caught diseases quickly. Thousands of sailors and steamboat workers also introduced diseases as they passed through the port. The filth (air, water, ground pollution and garbage) in New Orleans, as well as the surrounding swamps, attracted disease-carrying insects and polluted the water supply. Businessmen and politicians who wanted goods and people to keep coming to Louisiana ignored or purposefully covered up the problem of disease and death. To maintain a wide-open port free of quarantines, business interests tried to convince newspapers and directories not to publish negative news or publicize the astounding number of deaths in New Orleans. Morticians and ice providers gouged prices for coffins and ice for the poor.

The death rate ranged from a low of thirty-six per one thousand (in the late 1820s) to a high of one in fifteen (during the summer of 1853). Over twelve thousand people died of yellow fever in New Orleans that year, marking the single highest annual death rate of any state during the entire nineteenth century.

Diseases repeated themselves. A yellow fever epidemic arrived annually on the backs of mosquitoes, and during the hot months, mosquitoes were

Keystone View Company published this stereograph of a New Orleans cemetery in 1929. *Courtesy of the Library of Congress.*

everywhere. New Orleans was surrounded by water—some open (Lake Pontchartrain) and some marshes. In the French Quarter, fountains, watering holes and gutters collected water. Peering into courtyards and hearing the faint trickle and splash of a fountain, locals didn't worry about the bugs that water features attracted. In the mornings and evenings, people could be a magnet for insects, especially if they were near water. Large swarms of mosquitoes swooped down in summer at dusk attaching to the legs and devouring tender skin. Besides leaving behind itchy welts, mosquitoes spread diseases like yellow fever.

Victims of disease were immigrants, children, laborers and the poor. The wealthy could escape the plague by fleeing the city during the most dangerous months (June to November) and affording good health care and clean surroundings. When it was scorching, balloons of mosquitoes traveled about. Caterpillars fell from the oak trees, lice hid in animal fur and rats cocooned in the moist leaves of banana trees. Bacterial infections were frequently fatal. Before germ theory, caregivers went from patient to patient, unknowingly carrying the bacteria on their instruments and their unwashed hands. Some had the sick "bled" at the first sign of fever, which further collapsed their strength.

Yellow fever continued to plague Louisiana until 1905, the year of the last major epidemic. Before scientists at the turn of the century discovered that mosquitoes carried yellow fever, other serious epidemics affected New Orleans in 1878. In an epidemic year, the mortality rate could reach as high

as 60 percent of those who contracted a disease. Because people died faster than graves could be dug, the popular saying developed that pretty soon people would have to dig their own graves. There were no funeral homes. Many bodies couldn't be packed with ice but had to be put underground soon. The very poor who couldn't afford tombs or crypts were buried in unmarked mass graves and, during epidemics, one on top of another. So many died of yellow fever and cholera back then that carts went down the streets and circled around to pick up dead bodies. Corpses might lie for days in contaminated rooms or in gutters. Thousands of children were put in orphanages due to the death, unemployment or desertion of one or both of their parents. Many were left unsupervised.

Medical Care

Medical care was hard to come by. Children and pregnant women were the most fragile. By the late stages of pregnancy, almost anything could go wrong. A pregnant woman had to rely on relatives and neighbors and a midwife, if she could get one to aid in the birth. On the streets, female caregivers with herbs and home remedies were the only clinicians for people of color. However, in a time when doctors used violent methods (like bleeding) to treat patients, the wise regimen proposed by many Voodoo practitioners (herbs, tea, fresh air, fruit, flowers) often had a stronger effect. The sick cared for by the African American and Creole fever nurses with herbal teas, cooling baths, massage and nourishing broths were often more likely to survive.

WIDOWHOOD AND MOURNING

At age sixteen, before she was married, Marie Laveau gave birth to a daughter, Felicité, who lived. At age eighteen, she successfully birthed a second daughter, Angèle. Tragically, both of these daughters later died, and there is little historical evidence to explain what happened to them. They are recorded as born but seem to have vanished.

There is a lack of historical clarity about Marie Laveau's timeline. Much of scholarship is based on marriage certificates and baptism certificates, mostly from St. Louis Cathedral. Sometimes, baptism didn't happen right after the baby was born. In any case, some think Marie was born in 1794,

though most scholars say it was 1801. A wedding was recorded in 1819 to Jacques, making her at least eighteen years old at that time, and baptismal records for her daughters came out in 1817 and 1820.

An additional major loss was the disappearance of her husband. No one knows why or how Jacques disappeared. Though he was not buried in New Orleans, five years after loss of contact, Jacques Paris was declared dead. Alone and childless at age twenty, Marie Laveau became known as the Widow Paris. She joined the large sisterhood of widows in New Orleans in the 1820s (32 percent of adult women and 61 percent of women over age sixty). This statistic seems high until we recall that back then, women married younger and marriages had shorter life spans. A dire situation became worse when men left their assets to their children, not their wives. Widows often had to find new homes.

Some, like my widowed great-grandmother Hartel, fended for themselves by renting out rooms in their houses or taking in sewing, cooking and doing laundry for others. Few remarried. Many sought asylum with relatives or institutions. Only 5 percent of men were widowers because they quickly remarried.

A similar statistic is true today. A U.S. Bureau of the Census study estimates that widowers are ten times more likely than widows to find a new mate, and 61 percent of men have remarried by twenty-five months after a spouse's death. (Younger widows are more likely to wed than older ones.)

Back in the nineteenth century, widows might effectively be rendered non-persons. Outside of the legitimizing context of property ownership or marriage, they had limited means of economic survival. Many ended up wards of the state where they lived. Some received small stipends. An act of Congress of July 7, 1838, granted half-pay and pensions to certain widows. However, Marie's husband had disappeared, and she was an African American living far from Washington.

Voodoo Life

Marie found solace in prayer. Voodoo wasn't a major part of Marie's life as a girl, but both her grandmother and her mother practiced Voodoo. Marie had watched what her grandmother, her mother and her aunts did. In mourning, Marie embraced Voodoo. She soon learned she needed a calm mind to access the spiritual world and an absence of ego and pride when conversing with spirits, ages older and wiser and infinitely more powerful than she.

Meditative practices taught her to control and overcome emotional turbulences because the main method of communication with spirits was letting them inside herself as the medium. Prior to possession, Voodoo practitioners could obtain purification through ritual bathing, using ingredients like sage, sandalwood powder, salt and mint. She would rid herself of residual negative energies, which she picked up through venturing outside or even from her own surroundings. Burning sage at home also provided a clearing for any ritual. She prayed long and hard.

But Voodoo was a very private thing, and it continued to be that way because of the fear it instilled in many white Louisianans. Some worried the secret meetings of Voodoo practitioners would result in an uprising. Others claimed that the uncontrolled gatherings of Voodoo would give way to extreme hedonism in a city already devoted to pleasure.

Privately, Marie did living research, learning about the religion from Voodoo practitioners. She listened intently to what they could tell her. Marie couldn't get answers easily. Due to fear of repercussions, many Voodoo practitioners wouldn't talk. New Orleans Voodoo was essentially an oral tradition, practiced by many who couldn't or feared to write about it. No religious texts existed; there were no writings anyone could read to Marie. Like many free people of color and enslaved peoples, Marie Laveau couldn't read or write.

Catholic Life

Marie discovered similarities between Voodoo and Catholicism. The Voodoo supreme being and the spirits and ancestors who served as intermediaries became the Catholics' God, the Father, Mary the Blessed Mother and the legion of saints. The chanting, elaborate costumes and charms of Voodoo resembled the music, vestments and miracle-working relics of the Catholic Church. Marie moved easily between the two as the occasion required. Voodoo was a spoken tradition, but so was Catholicism; Priests said the Mass, heard confession, presented the liturgy at Christmas and Easter, led novenas and blessed objects. Voodoo priestesses directed rituals, gave consultations, performed healing ceremonies and formulated charms for individual clients to resolve difficulties with relationships, money, employment or health.

Solace of Matriarchy: Woman Priests

Although she always claimed to be a Christian, Marie liked the fact that almost from its first days in Louisiana, Voodoo seemed to have been a matriarchy available to African Americans. White men (priests) controlled the Catholic Church. White men (government officials) controlled the political power. White men (doctors) controlled the clinics and hospitals. White men (journalists) controlled the newspapers. White men (lawyers) controlled property rights and the transference of money. However, since its first days in Louisiana, women could be leaders in Voodoo. This religion empowered many African American women through matriarchy.

Altars

Like her mother and grandmother had done, Marie made home altars, and if she got a request, she put a reminder of that person on the altar. She asked her ancestors to watch out for him or her and left candles burning all night. Today, some say intent is all, that (like a placebo) intent will cure us if we believe. This may be true, but undoubtedly Marie had the healing touch, prayed powerfully and cured many.

Treating the Sick

Marie had never questioned about her grandmother treating people. It hadn't deeply interested her. If the spirits were meant to be part of Marie's life, they were going to have to go out of their way to do so. And they definitely did. She wanted to be part of her ancestral past, of people who weren't here anymore, and to continue to connect with the spirits of her loved ones. She felt humbled and honored, and that counted for more than any of the mockery that some people sent her. As a widow, she was totally dependent on God and neighbor. She was honored to be able to serve others in a city where so many, especially women, needed support. Just the words "The spirit goes with you" or "Everything will be fine" brought solace.

Literacy

Voodoo gave Marie a way to connect with an inner power that made her feel strong despite the difficulties of being alone. Even as late as 1870, 80 percent of African Americans were not literate, as opposed to 20 percent of whites. A law of 1830 had forbidden teaching slaves to read or write on pain of imprisonment for up to twelve months. Freed African Americans had few options for learning, and women even fewer. While her father, her husband and her second partner/"husband" (Caucasians couldn't legally marry African Americans) all could write and signed their names with flourish in the church registry, Marie signed with an *x*.

Despite her lack of formal education, Marie Laveau needed to be alert, to remember, to act strong. She was determined to do something to lessen the misery about her. But she needed to make money in a world where women had almost no opportunities for employment. Marie began praying and thinking about what she could do. She fulfilled her destiny of becoming a leader, a businesswoman and a healer. She followed the path of many brilliant unschooled leaders: Joan of Arc, a peasant girl leader of armies of France; Bernadette, a shepherdess who announced the miracle of Lourdes; and Charlemagne, the eighth-century ruler who was King of the Franks and the Holy Roman Emperor but also illiterate. Lots of people and civilizations were mighty although individuals couldn't write.

Glamour

Marie was impressive: tall, stately, with glamorous robes, huge gold hoop earrings and a seven-point tignon, or cloth worn as a turban. This headdress resulted from institutionalized racism in the form of sumptuary laws passed in 1786 in Louisiana. Called the tignon laws, they prescribed and enforced certain public dress for female *gens de couleur* as a way to conceal their attractiveness. Back then in Louisiana, women of African descent vied with white women in beauty, dress and manners. A standout physical attribute that separated them from their white female counterparts was their hair. This perceived threat to white women's relationships with French and Spanish Creole men incurred the jealousy and anger of their wives, mothers, sisters, daughters and fiancées.

Nevertheless, despite or maybe because of these laws, some African American Creoles seeing the importance of beautiful hair to white women

became their hairdressers. That is what Marie decided to do. Perhaps during her walks throughout the French Quarter between Canal Street, Rampart Street (named for the ramparts that formerly defined the city), Esplanade Avenue and the Mississippi River, she noticed the attention bestowed on the virile and the beautiful. Perhaps she began by doing the hair of friends. A hairdresser is an intimate profession; you touch people personally when you massage their heads. (Cranial massage is now a big source of healing in America.)

Women let their hairdressers see them at their worst, physically and emotionally. As Marie did women's hair, they began sharing secrets and confiding in her. Marie started to pray for them and to be very grateful for the role that Voodoo played in her life. It sensitized her to deeper things she and her clients were supposed to be paying attention to. It made her start relating even more to her grandmother, a practicing Voodooist. As she prayed and learned through advising others, she grew in her identity and strengthened her commitment to serving others.

Marie began caring for her customers with powerful herbs (for example, ginger, St. John's wort and a specially concocted green tea) and prayers. She couldn't save her own little daughters and husband, but she saved many others.

In 1900, streetcar tracks lined the neutral ground on Esplanade Avenue in the Garden District. This photograph was published by Detroit Photographic Company. *Courtesy of the Library of Congress.*

Second "Husband" and More Deaths

A year after the death of Jacques Paris, Marie began a relationship with Louis Christophe Dominick Duminy de Glapion, a white man of French descent who had fought gallantly against the British in the defense of New Orleans. Although she couldn't marry him because he was white, some scholars say he legally changed his race to a free person of color to be with her. Marie and Christophe took up residence together and lived as husband and wife for the rest of their lives, some thirty years.

Prayer, Ritual

Shortly after she moved in with Glapion, Marie found out she was pregnant. And when her daughter (child number three) Marie Heloise Euchariste was born on February 2, 1827, and lived, Marie sent up prayers of gratitude. Soon, Marie was pregnant again. When that baby (child number four), Louise Caroline Glapion, was born healthy, Marie was again deeply thankful.

Infant Deaths

But then the deaths began, the long parade to the graveyard. Baby Louise died at eight months. When pregnant again, Marie gave thanks to her ancestors. She survived the birth, but a few days later, her first son (child number five), Christophe Glapion, died. A year later, Marie's second son (child number six), Jean Baptiste, died at a few days old. Then Francois Maurice Christophe (child number seven) was born on September 22, 1833, and eight months later he died. Never one for self-pity, Marie threw herself into work with Voodoo, raising money and providing herbs, food, medications, clothing and bedding for the poor. The spirits heard Marie's desperate evocations, and Marie Philomene Glapion (child number eight) lived.

Worst Death: Child Number Nine

Marie was blessed (and cursed) at thirty-seven with a surviving son, her ninth child, Archange Edouard. He lived until the age of six and then contracted yellow fever. His death was all the more devastating because Archange had outlived the age (four years old) before which most children at the time died.

CEMETERY

Marie's children were buried in the white part of the cemetery because she was "free" and her partner, Glapion, was white. At that time, segregation prevailed—even for the dead in New Orleans. There was another section of St. Louis Cemetery for African Americans.

Marie wanted to help others and become a Voodoo priestess. Prior to Marie, the New Orleans sect had been subject to many schisms and changed rapidly from year to year. In Marie's early years of involvement, so much secrecy prevailed that many Voodoo practitioners themselves didn't know the true identity of their queen. Marie named herself queen, moving past any who opposed her. Few did.

Among the fifteen Voodoo queens in neighborhoods scattered around nineteenth-century New Orleans, Marie Laveau became known as *the* Voodoo queen, the most eminent and powerful of them all.

Ornate vaults preserve the bodies of deceased individuals and families in St. Louis Cemetery. The original photograph was published by the Detroit Photographic Company. *Courtesy of the Library of Congress.*

SPEAKING TO ANCESTORS AND POSSESSION

Spirits and ancestor communication, so prominent in Voodoo practice, became important to Marie as her children died. The term *Voodoo* or *Vodun*, in fact, literally means "Spirit" in the local Fon language of modern-day Benin, Africa. Many of the actual practices of the Voodoo faithful center on the relationship with the dead. Voodoo practitioners believe in the power of spirits, who have influence over nature and human existence.

Spirits were always being added, as so many people were dying in New Orleans, and Voodoo encouraged connecting with the spirits of the graveyard. Marie wasn't afraid to go somewhere haunted or to call forth the dead. And contact with spirits was direct; the most direct form was spirit possession, which took place during ritualistic dances venerating the spirits of the ancestors.

For Marie, possession became a beautiful way she communicated with the dead. The spirit incarnated in her body, thus enabling it to literally walk with her. She was in an ecstatic state for a minute, and then she could talk to the spirit. Sometimes, she or others would ask for advice about something traumatic. Possession could take place for several hours or several minutes.

Marie began communing with a snake, which some say she called La Grande Zombie, which means an undead person in Haitian folklore. Since the Haitian Vodou god was a serpent, many Voodoo practitioners lauded dancing with it. In the Haitian creation myth, the serpent spirit went across the sky and created a rainbow and fell in love with it. While a positive emblem in Voodoo, the serpent symbolizes evil or the devil in Christianity.

VOODOO EVENTS IN CONGO SQUARE
AND LAKE PONTCHARTRAIN

Rivals fought for dominance over the Sunday Congo Square dances. Marie Laveau allegedly presided over them, shocking followers by her sensuous moves with a snake. She attracted visitors from all over the world curious about Voodoo dances, which some claimed were scandalous. In the 1830s, New Orleans was the wealthiest city in the nation, the third-most populous city (roughly fifty thousand) and the largest city in the South. Marie profited from that by selling tickets to her dances and events.

In the 1830s, Priestess Marie also began gathering with groups in the evenings for secret ceremonies along Lake Pontchartrain. She led rituals,

danced to venerate the spirit of the ancestors and hosted annual feasts. She created St. John's Eve on June 23, a celebration of the summer solstice that included a head-washing ritual, music and festivities. By 1874, her religious rites on the shore of Lake Pontchartrain on St. John's Eve attracted some twelve thousand black and white New Orleanians.

Dr. John and the Underbelly of Voodoo

Rivals came to town. Dr. John traveled from Senegal, Africa. A large man with facial scars, he introduced himself as a Senegalese prince. He eventually became a prominent Voodoo king in late nineteenth-century New Orleans. Bringing the knowledge of the craft, as well as charms and poisons, from his home country, he joined an already prominent Voodoo community.

Some say that he was Marie's lover, mentor and professional rival. Dr. John saw Voodoo as a way to make a fortune and started up a brothel on Lake Pontchartrain. He concocted and sold charms. He discriminated against African Americans and only honored those in his family who appeared white. He called himself a doctor, although he had no degrees.

Some saw that Dr. John was exploiting Voodoo and selling fake curses for profit. As his fame and trickery increased, he bought a property on Bayou Road and began purchasing and abusing female slaves. Later, he boasted of having fifteen wives and over fifty children. Thousands came to his home, which contained snakes, lizards, embalmed scorpions and animal and human skulls, the last stolen from graveyards. Enjoying the fear he inspired, he placed and lifted curses for a fee. Persons he cursed weakened and wasted away—or went mad. This was, and is, the real terror of malevolent sorcery. In sorcery, it is believed that intent is always the determining factor, and negative intentions can be fierce and do harm. Seen as a con artist of Voodoo, Dr. John died in misery after a violent life of abusing others.

Brothels

Influenced by this nefarious user of powers, Marie ran a house of assignation, or "love hotel," for young women by Lake Pontchartrain. (Marie Laveau's daughter who took over her name and business also associated with brothels.) A "house of assignation" is a more formal, legal and euphemistic term than

the synonymous "house of ill repute." Her ceremonies appealed to men who sought adventures of an erotic nature.

Out on the shore of Lake Pontchartrain, Marie the First had built a white cabin (twenty by thirty feet) known as Maison Blanche. Tales circulated of hidden and secret rituals erupting deep in the night, complete with snake worship, wanton dancing, drinking and lovemaking. Almost a third of the worshipers were white, desirous of obtaining the "power" to regain a lost lover, take a new lover, eliminate a business partner or destroy an enemy. Lavish parties occurred there, with secret meetings for politicians and high officials. Marie offered champagne, fine food, wine, music and naked women dancing. Police feared that if they crossed Marie, she might place a spell or "hoodoo" them. They never raided her parties.

RIVALS

Powerful contacts allowed Marie to subdue competitors. Dr. John and the rival queens were disposed of, sometimes with threats or sometimes, it is said, because she used such powerful gris-gris (African or Caribbean charms) against them that they either died or left the city. Sometimes, she may have eliminated them by brute force, extracting a promise to abdicate their thrones or serve under her as sub-queens.

CHARITABLE CONTRIBUTIONS

A strong leader, healer and adviser, Marie stood on the gallows ministering to the condemned, and in her later years, she took daily interest in helping the inmates at New Orleans parish prison, a short walk from her St. Ann Street home. She almost saved some from execution, comforted others as they awaited it, mercifully dispatched some with gumbo (a New Orleans favorite soup) and won a stay for a few. She spent mornings with convicted murderers before their executions, praying with them before altars she erected in their cells. She moved between visiting the sick in hospitals and meeting with, advising and sometimes intimidating the wealthy. Many men paid her to have their illicit affairs hushed up.

Prayer

Marie transformed her misery into medicine for others, using her losses to spur her on even more to keep others' children alive. She avoided despair by dancing for the living and praying for the dead. She had so many spirits now on the other side. (Of her nine children, two had survived: Marie and Philomene.) But she knew she wasn't the only sorrowful mother.

Caretaker

She became a caretaker and learned how to heal people, creating a band of blood women walking with amulets, charms, prayers and open arms across the French Quarter. She had to find twice as much joy because she had to bring it to the despairing. Going around the Quarter was a lesson in urgency because she became the attractor for her endangered people, many of whom wouldn't be around long. She was always there when needed and offered the kind of conditions for her people to thrive. Aristotle says, "We become just by performing just actions, temperate by performing temperate actions, brave by performing brave actions." Many in the community deeply respected Marie.

Brave, loyal and resilient, Marie entered houses and places of infection, consoling others with her words and potions. She gave desperate people belief in a higher power and led them to find a spiritual meaning in death. When people were on the way down, Marie would do whatever was needed, whether it was cooking a good meal for a prisoner or terrorizing a judge. She was said to have mastered the small kindnesses, treating the hopeless, comforting the motherless, receiving the homeless. For example, she invited Native American merchants from Congo Square to set up camp in her yard rather than stake out spots roadside.

Marie wasn't destroyed by the mournful sounds of the dying, even when they were her children. She revitalized her world with her gris-gris, dancing and visitations from spirits.

African American Woman Leaders

Marie's generosity prevailed in a time when women, especially slaves or newly freed slaves, had few opportunities to learn and women leaders went unheralded. Popular history texts only identify a handful of African

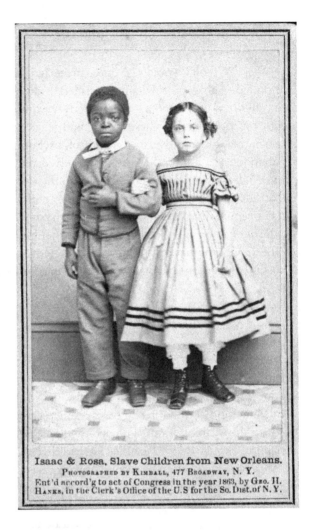

Isaac & Rosa, Slave Children from New Orleans.
Photographed by Kimball, 477 Broadway, N. Y.
Ent'd accord'g to act of Congress in the year 1863, by Geo. H.
Hanks, in the Clerk's Office of the U.S for the So. Dist. of N. Y.

Isaac White and Rosa Downs were two enslaved children from New Orleans, pictured in this 1863 photograph by H.M. Kimball. *Courtesy of the Library of Congress.*

American women trailblazers in the nineteenth century, though we know many more went unnoticed.

Despite initial opposition, a Louisiana enslaved person, Milla Granson, had conducted "midnight school" in her cabin, her activities eventually making it legal to teach a slave to read. Marie Bernard Couvent, another enslaved person, had willed all her money to the maintenance of a free school for the African American orphans of the Faubourg Marigny, near the French Quarter. In 1842, Henriette Delisle founded her religious order of African American nuns, the Holy Family Sisters, who staffed many Louisiana schools, orphanages and asylums.

Orphans

Like these Creole women, Marie protected the unschooled and the abandoned. She supported impoverished widows who, rather than have their children get work as indentured servants or be left unattended, sought out orphanages where they could leave their children temporarily or permanently. Sensitive to the lack of asylum for the growing number of abandoned children, Marie endowed orphanages, raised her three grandchildren and gathered orphans from the street.

Considering the good works, healings and performances of Marie Laveau and her reputation throughout town, it's amazing so little was written about her during her lifetime. Rather, the news often presented unfavorable views of Voodoo. Some newspaper articles depicted practitioners as speaking in almost incomprehensible dialect or being unintelligent.

Legacy and Death

For fifty years, Marie Laveau injected herself into every aspect of New Orleans life. Many condemned her, while others worshiped her. She died on June 17, 1881, in the four-room house on St. Ann where she lived most of her life and is buried in the oldest cemetery in New Orleans, St. Louis No. 1, in the Glapion tomb. The pedimented three-vault tomb, bearing the inscription Famille de Vve Paris née Laveau (Family of the Widow Paris born Laveau), was once said to be second only to Elvis Presley's grave as the most sought-after burial site in the United States. Unfortunately, because frequent visitors were damaging Marie's grave site, it can't be openly visited anymore. You need to get permission from the Catholic Archdiocese on Walmsley Avenue or join certain tour groups that have permission.

An amazing 111 people are interred in the three tombs Marie is said to have owned in St. Louis Cemetery. Only 24 were family members: Christophe Glapion, 4 of their children, 10 grandchildren, 2 grandnephews and 7 great-grandchildren. The rest of the dead—neighbors or unknown friends, as well as 46 infants—attest to Marie's generosity, even in death.

Marie Laveau stars in New Orleans because she was a great Voodoo queen. Fearless, she led people into realms of holiness and physicality heretofore hidden in slave-ridden New Orleans. She instilled fear and courage in those who opposed and those who followed her.

New Orleans misses Marie Laveau. Cottages similar to hers remain on St. Ann, although hers survives only as a plaque. A beautifully renovated "St. Ann's Cottage" houses tourists. Nearby, Madame John's Legacy, a colonial house (whose name was inspired by George Washington Cable's 1874 story about a mistress's inheritance), receives the public. Rampart Street (near where Marie lived) is enjoying gentrification, and Congo Square has reclaimed its celebratory status.

Marie Laveau was more than a sorcerer of the soul; she was a pioneer. She brought the power of religion, mercy and enchantment into full focus. Because of her resilience, we still study her today for clues to her audacious spirit. Chapter 5 will explore key sites in New Orleans associated with Voodoo and Marie Laveau.

VOODOO SITES IN NEW ORLEANS

by Rory Schmitt

Introduction

When's the last time you went to New Orleans? Strolled down Pirates Alley behind St. Louis Cathedral savoring a scoop of Häagen-Dazs mint chip ice cream? Smelled the air after a summer storm, soaked up the heat rising from the sidewalk, watched dew clinging to an oak tree? Once you meet New Orleans, memories of it will gnaw at you for decades.

Peering through the lens of Voodoo, let's dive more intimately into the city's identity. Together, we discover important Voodoo sites, including the New Orleans Healing Center, Island of Salvation Botanica, the International Shrine of Marie Laveau and her tomb in St. Louis Cemetery No. 1. We'll also uncover fierce preservers of the history of New Orleans, such as the New Orleans Historic Voodoo Museum and the Historic New Orleans Collection. Lastly, we will learn about the Voodoo Spiritual Temple, where services such as African bone readings help people find love.

First, let's view my narrative of visiting the New Orleans Healing Center in order to visualize a firsthand experience through another's eyes.

Voodoo in the Community: The New Orleans Healing Center

Torrential downpour. The first time I went to the New Orleans Healing Center, buckets of water fell upon us: my father (Dick O'Neill), Olivia (my

three-year-old daughter) and Rowan (my one-year-old son). We unloaded into the center's small back parking lot, racing inside to get out from the rain. Immediately, the air changed indoors; it felt cooler and smelled healthy. Looking to my left, I spotted the New Orleans Food Co-Op.

We rolled farther into the community center, past a theater and community meeting space, a police department and a barber clipping men's hair (cheekily called Two Guys Cutting Hair). At Arbor House Floral, we purchased a fresh bouquet of white roses and lilies for our priestess friend. With grace, she humbly placed them on an altar in her botanica as an offering to the Lwas.

At Spotted Cat Food and Spirits, we sipped cappuccinos as jazz musicians serenaded the crowd. Behind them, cars on St. Claude Avenue crawled past, rain sloshing their windshields. *Splash!* Just another Wednesday afternoon in New Orleans.

In the central lobby of the Healing Center, high ceilings created an open, airy space. Tall art sculptures reminded me of Mardi Gras floats, with their large, curvy and exaggerated features. A papier-mâché lion wearing a crown smiled upon us, dwarfing my preschooler as she pranced playfully about. The creatures looked jovial, celebratory and a bit bawdy; a smiling female skeleton drank from a Jack Daniels bottle under a New Orleans street sign. No barriers, barricades or signage prevented visitors from getting up close to the artwork and appreciating the details.

Together, a husband-and-wife team envisioned the 5,500-square-foot community center, which opened in 2011. Developer Pres Kabakoff and business owner Sallie Ann Glassman steer its evolution, providing revitalization to the once-blighted neighborhood. The center provides social services, hosts public performances and embraces the arts. For instance, the Sacred Music Festival converged multicultural musicians in March 2017, asking, *Can music heal?*

The ideology of the Healing Center shares with Voodoo the power of the community to ignite healing. Local scholar Dr. Martha Ward told me, "Voodoo provides help in a situation that is really hard and hurtful but you didn't create for yourself....Voodoo is a way of having some agency in a world that has a lot of power reigned against you."

A contemporary sculpture of a burlesque skeleton at the New Orleans Healing Center references Voodoo themes of death and revelry. *Photo by Rory O'Neill Schmitt.*

Every time I've visited my hometown in over a decade since Hurricane Katrina, I see how the city is still recovering. The New Orleans Healing Center reminds us of that after terrific tragedy and terrible suffering, we can be restored. With faith, we nurse our wounds. Once we recognize our need to claim our own right to heal and uncover our core strengths, we look around and realize: We are not alone. And we never will be.

ISLAND OF SALVATION BOTANICA

Imagine a place where you could be protected from harm, ruin or loss. A space that encouraged friendship and union with the Divine. Wooden angels floating from the ceiling greet you as you enter the Island of Salvation Botanica in the New Orleans Healing Center. Here, you can discover spiritual items, such as hurricane candles featuring Catholic saints, vibrant royal blue paintings of Mother Mary (or Erzuli Freda) and tiny car statues of St. Anthony (or Papa Legba). Miniature dancing skeletons evoke the Day of the Dead, while a black chicken foot adorned with crimson feathers serves as a Voodoo fetish.

Visual art at the botanica serves spiritual purposes. It offers religious art objects that you can hold, touch and carry on you or in your car. Symbolic items are part of the sacred practice of day-to-day spirituality for many Voodoo practitioners. Since the artifacts look beautiful, they bring *joy*. As they are recognizable, they permit believers to feel *safe*. Because they can be easily used, they *empower*.

Storeowner and Vodou priestess Sallie Ann Glassman pointed me to a back room where the mystery happens. Focusing her intuitive powers and entering trance, she does crystal ball divination, gives spiritual consultations and performs readings of past lives. Sallie Ann also creates oil and pastel visionary paintings of people's souls.

The Island of Salvation Botanica is committed to the community, and in 2017, it promoted a public ceremony against racism to honor the people of Charlottesville. Attendees stood up against bigotry, homophobia, misogyny and hatred. They lit red candles and honored Ogou, the Spiritual Warrior (represented as St. James Major), with offerings of rum, unfiltered cigarettes, cooked meats and iron.

Anba Dlo Festival

For nearly a decade, the Anba Dlo Festival has captured New Orleans Voodoo with its concern for nature, commitment to community and celebration of life at the New Orleans Healing Center. In Haitian Kreyòl, *anba dlo* means "beneath the waters." At a scientific symposium focusing on the water crisis facing New Orleans, participants voice their concern for Mother Earth and search for ways to heal environmental wounds. The festival calls community members to build their courage inventory. It is much easier to flee an environmental crisis rather than face it head on.

Afterward, New Orleans–style revelry begins when psychic readers, acrobats and burlesque dancers arrive. A Halloween parade invites local walking procession groups, such as the Pussyfooters, Muff-a-Lottas and Intergalactic Krewe of Chewbacchus. Costuming is deeply engrained in New Orleans culture. For instance, one summer night, I joined friends for a costume party. One man wore only white brief underpants and a sign taped to his back: Worst Nightmare. Masquerading invites individual freedom, offers opportunities for brave expressions and creates a hospitable atmosphere to share in others' fantasies and fears.

At midnight, Vodou practitioners of La Source Ancienne lead a spiritual ceremony next to the Healing Center's mermaid fountain, created by local artist Ricardo Pustatino. They recognize the ruling Lwa, La Sirene, the queen of the seas.

Marie Laveau

Though Marie Laveau has been deceased for over 130 years, the Spiritual Mother of New Orleans still resides in the city. People call on Marie Laveau for strength in times of great difficulty, for solutions to overwhelming problems and for comfort in deep sorrow.

The International Shrine of Marie Laveau

As you step up to the statue, beautiful Marie Laveau smiles as she towers above you. A sculpture originally created by Ricardo Pustanio for St. John's Eve Festival in 2016, Marie later found her way to the New Orleans Healing Center and was set up as artwork on display outside the Island of Salvation

Botanica. Visitors began leaving her notes and bringing her offerings. The community transformed the sculpture into a spiritual shrine.

Marie possesses a clear complexion, rosy cheeks and gentle features. She looks like Marie Laveau in her thirties, a glorious age when she was coming into her own with Voodoo and strengthening herself through trials of motherhood. Solid, she will not easily tumble. Marie stands tall, looks ahead and shows neither fear nor judgment.

A sienna serpent hangs over her shoulders, pointed tongue protruding, its head slightly rearing at her chest. Long, the snake's body wraps around her neck, and its tail falls past her hips. Still, Marie is not afraid. The snake recalls the snake dances that Marie performed in Congo Square.

Notable is Marie's dramatic blood-red headscarf, which adds six inches to her height. Tightly twisted pieces of cloth, composed of blocks of red with thinner white lines, create a sculptured hairpiece, perhaps significant, as she was a self-employed hairdresser. Additionally, it reminds viewers of New Orleans history: as a free woman of color, she was forced by law to cover her hair—a futile attempt to detract from her awe-striking beauty. From 1786 into the nineteenth century, women of color fought this restriction by wearing elaborately designed and brilliantly colored tignons.

Fabric from her headscarf cascades down and emerges from the center of her body, where her light blue cloak is partially opened. The cerulean cloth puddles to the floor, where it is inscripted with a painted vèvè. At her chest, she embraces a figure with an emaciated skeleton-like face, chicken foot fetishes and a perfume bottle with her signature: XXX.

The Marie Laveau statue evokes Christian iconography of the Blessed Mother. Like the Mother of Christ, she is honored in her cloak of blue and white. Marie projects her nurturing and trustworthy qualities. The statue also recalls the Black Madonnas, numerous medieval statues in Europe with dark skin pigmentation.

Marie stands on a three-foot-high circular base, composed of black skulls on columns, with black paint oozing down. Underneath this base, a marble column holds an official plaque with a fleur-de-lis. Additional markings include vèvès, encircled crosses and red and black handwritten XXXs.

On the wall behind the shrine are additional artworks, such as an Erzuli drapo and framed historical paperwork relating to Marie Laveau. Delicate blue and clear glass organic art forms dangle from the ceiling. The interaction between these intentionally integrated objects gives birth to a peaceful aura.

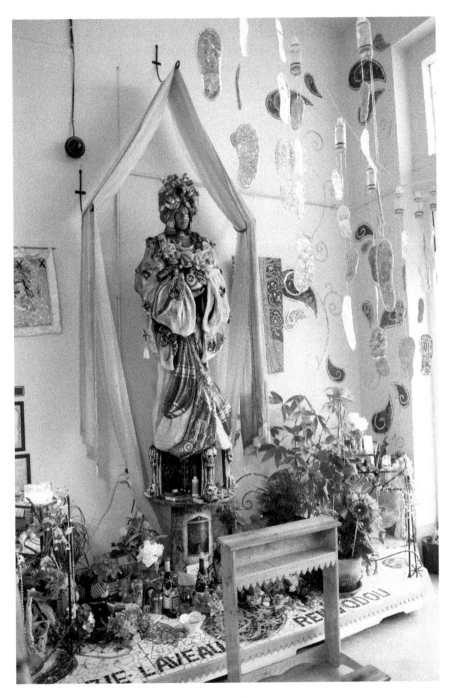

The International Shrine of Marie Laveau is visited by believers of many backgrounds, who pay homage to the Voodoo Queen with personal offerings and prayers. *Photo by Rory O'Neill Schmitt.*

Additional features surround the sculpture, protecting a safe spiritual space. Under the statue is a long platform that rises about six inches off the floor. Explicit signage, "Marie Laveau Ren Vodou," cements her place in the world. Rich turquoise, royal blue, white tiles and mirrors compose the Voodoo Queen's mosaic ground.

Through a community effort to create a shrine, members donated tiles and mirrors. The artist restructured something new based on disparate parts. Perhaps the mosaic is a metaphor for Voodoo. As a way of healing and connecting, the mosaic provides each piece a new home, repurposing what was discarded and infusing revitalized meanings.

Devotees pay homage to Marie Laveau and recognize the Divine Feminine by bringing offerings of flowers, wine, rum, hurricane candles, Catholic prayer cards, Mardi Gras beads and doubloons. Some write down their private petitions, fold up the paper and place it on the shrine. The openness of the participatory community catapults this spiritual space into the twenty-first century. A shrine must no longer succumb to an altar fenced off with iron gates in a private church. Sometimes, physical barriers lead to spiritual barriers.

Before you leave the shrine, consider taking a peaceful moment for prayer or meditation at its wooden kneeler. The shrine reminds viewers that they are one part of something much grander than their individual selves.

Marie Laveau's Tomb

Additional areas to explore Voodoo downtown include the tomb of Marie Laveau. New Orleans buries its deceased in aboveground vaults that create their own city of the dead. In St. Louis Cemetery No. 1, Marie Laveau's recently renovated tomb is a small white stucco rectangular building with a pointed roof. A marble historic monument sign reads: "Famille de Vve Paris née Laveau" (Family of the Widow Paris born Laveau). Inside, 84 bodies are preserved. In her research, Dr. Carolyn Morrow Long found that along with Marie Laveau, only a portion of the deceased, who were interred between 1834 and 1957, were actually family members. Marie practiced her generosity from beyond the grave.

Second to the grave of Elvis Presley, Marie Laveau's burial site was the most frequently visited in the United States. Thousands of visitors made

pilgrimages to her tomb. Humbly, they offered her flowers, rosary beads and candles. Unfortunately, over the years, Marie's tomb suffered from destruction. Graffiti (often XXX markings) covered her vault, and bits of the tomb were stolen and taken home as souvenirs.

Since March 2015, to access Marie Laveau's tomb, you must be part of an approved tour group or a verified scholar. To request a research pass, you can apply at the Archdiocesan Cemeteries Office, which owns and operates the cemetery. Restricting access to Marie's grave might actually make visiting her site even more enticing. Some people have been known to jump the cemetery walls to gain an encounter with the tomb.

Symbolically, Marie Laveau's tomb serves multiple functions. It acts as a sacred place of remembrance, where devotees can get as close as possible to her and seek spiritual counsel. Additionally, visiting Marie's vault inspires spiritual and existential reflection. When people visit a grave, they might wonder, *Does the soul exist? Where did my loved ones go? Will I ever see them again? Can you help me, Marie?*

Historic Preservation:
The New Orleans Historic Voodoo Museum

Creaking open traditional French Quarter double doors on Dumaine Street, one might be greeted by Ms. Bonita at the front desk. Behind her hangs a radiant portrait of Marie Laveau, which the museum's founder, Charles Gandolfo, painted. She is cloaked in a cerulean dress with a plunging neckline, and her head is wrapped in a blonde tignon, from which golden hoop earrings peep out. She holds her hand softly at her chest. With her lips somewhat pursed, she sees you for all that you are. Mona Lisa–like, her eyes follow you.

For over four decades, the New Orleans Historic Voodoo Museum has served as a source of information about the unique, sacred spiritual practice of Voodoo. After paying for the self-guided tour, museum guests might slowly stroll down the dark hallway filled with portraits and a kneeler perhaps once owned by the famous Voodoo Queen.

A haunting 1954 jazz song, "Marie Laveau," often plays throughout the galleries. Louisianan Papa Celestin wailed:

Folks came to her from miles and miles around,
She showed them how to "put that Voodoo down."

This page: A portrait of Marie Laveau, created by the museum's founder, is a focal point in the lobby of the New Orleans Historic Voodoo Museum. Located in the French Quarter, this museum preserves and honors the traditions of Voodoo. *Photos by Rory O'Neill Schmitt.*

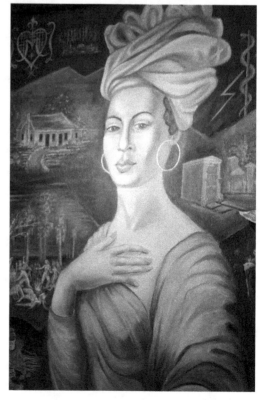

A Cultural History

To the Voodoo lady, they would go—
Rich, educated, ignorant, and poor.
She'd snap her fingers and shake her head.
Then tell 'em 'bout their lovers—livin' or dead.

Two galleries introduce visitors to New Orleans Voodoo art and cultural relics. The first room presents a closet blazing with red light. Every inch of this tiny space is filled with candles and pictures adorned with Catholic saints. In the room, from the ceiling to the floor, artifacts attest to Voodoo's diverse history. Wooden masks and human figurine carvings recall Africa's influence on Voodoo. And playful death imagery abounds. A little graveyard area holds human skulls with dollar bills rolled up and placed in their nostrils and eye sockets.

Meandering into the second room, additional illustrations of Voodoo unfold. I recall how Voodoo ritual behavior links Earth worship with individual intentions when they encounter a wishing stump (which mirrored Marie Laveau's on Lake Pontchartrain). Posted directions instruct you to make a wish on a one-dollar bill and roll it up. Place it on the stump, then knock or stomp three times. Lastly, express gratitude to the spirits. (At the front desk, a two-page museum handout explains that the Lwas are like politicians. When you ask them for something, you must give an offering in order to help talk them into it.)

In this gallery, altars breathe a sense of peace and purpose into the space. Iconography of the Virgin Mary and Erzuli Freda abounds: religious statues, devotional paintings and Greek metal art. The altars invite interaction with visitors. Stepping closer, one can get a sense of all the visitors who had come before and left their marks. Graciously, they shared offerings and also showed who they were; some people even placed Polaroid selfie pictures on the altars.

When people offer gifts to deities, they recognize human likenesses in the divine. They consider, *Maybe their ancestors and the Lwas enjoy smoking.* So they share cigarettes, matchbooks and lighters. They reflect, *If deities are like me, maybe they want to look and smell good.* So they give hairclips, lipstick and mouthwash. Lastly, they see Voodoo's perception of death as not a somber ending but a journey into another realm. In this next veil, spirits celebrate life and engage in revelry. Visitors might identify, *If spirits still like to have a good time, perhaps they'd enjoy a drink of rum (and some money, too)!*

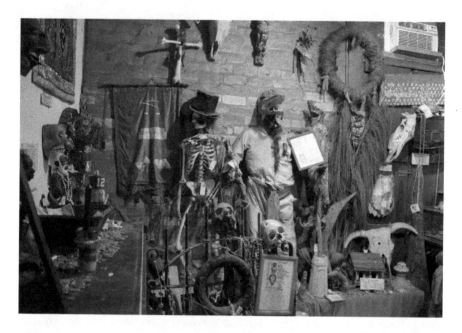

This page and opposite: New Orleans Voodoo is a syncretic religion, with influences from earth-based worship, Yoruba traditions and Catholicism. Elements of these diverse backgrounds are integrated in chromolithographs of saints, animal icons and death symbols at the Voodoo Museum. *Photos by Rory O'Neill Schmitt.*

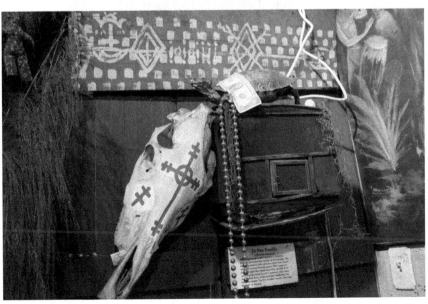

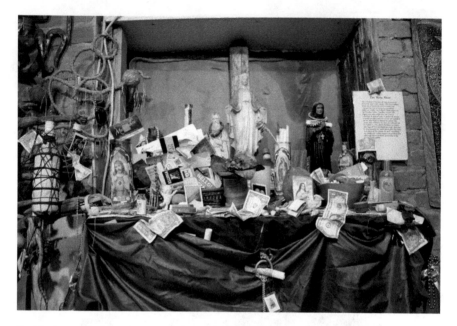

In this altar at the New Orleans Historic Voodoo Museum, one might notice the incorporation of the Virgin Mary. *Photo by Rory O'Neill Schmitt.*

ST. LOUIS CATHEDRAL

Upon departure, one can meander through the Vieux Carré and land in Jackson Square. Here, one may find an incredible brass band. Music ignites personal empowerment and agency. Snaking through a sea of tourists, one can next enter St. Louis Cathedral, the oldest Catholic cathedral in continual use in the United States. One might even imagine Voodoo Queen Marie Laveau praying the rosary, covered in a shroud mourning the loss of one of her seven children who passed.

Bright colors fill the high-vaulted ceilings with perfect Renaissance-like paintings of angels and saints. One might notice a worker fastidiously vacuuming the altar, showing the institution's devotion to creating a pristine space. It is a sacred space completely different than the Voodoo Museum.

Dark and small with low ceilings, when I visited, the Voodoo museum looked like it hadn't been dusted in a while. A museum analyst might notice a need to update signage or remove excessive items cluttering the galleries. However, Voodoo does not call for an illusion of perfection. Voodoo reminds

individuals to just let things be, let things age and just recognize how things are. New Orleans Voodoo is not an immaculate, organized or controlled religion with a prescribed scriptural text and religious hierarchy. The museum pamphlet even shared, "There's nothing consistent about Voodoo. The only consistency is the inconsistency of Voodoo."

THE HISTORIC NEW ORLEANS COLLECTION

In the French Quarter nearby is the New Orleans Pharmacy Museum on Chartres Street. One exhibit on Voodoo potions is inspired by the pharmacy's history. It was renowned for making Love Potion Number 9.

Upon arriving at The Historic New Orleans Collection, one signs into the visitor log and then might have a sort of disrobing experience. Placing most belongings into a locker, one can carry only the minimal items necessary to do research in the upstairs archive. The research center is committed to protecting the 35,000 documents and manuscripts and 350,000 prints, photographs and additional artifacts in its collection dedicated to the historical preservation of New Orleans and the Gulf South.

Here, individuals interested in Voodoo can encounter texts and images in the archive that can't be easily found elsewhere. For instance, one can find a sixteen-by-twenty-inch black-and-white photograph of Marie Laveau's house on St. Ann Street, which has since burned down. A back view, the historical photograph shows a two-story house with a chimney, shed and clothesline. Inspecting the photograph, viewers might imagine what neighbors witnessed from their windows.

More contemporary photography relating to New Orleans Voodoo can be found in the contact sheets of Michael Smith's photography. One exemplary photograph shows children happily dancing at a podium at the Spiritualist Church. (Dr. Ward explains this local religious community has ties to Voodoo.) Religious scholar Dr. Stephen Wehmeyer shares that Michael Smith was a valuable resource in his photographic collections of black vernacular culture in New Orleans. He points out that some believers prefer the term "Spiritual Church" rather than "Spiritualist."

Literature about New Orleans Voodoo spans decades of newspapers, pamphlets, theses, dissertations and books. One might be mindful of their different philosophical lenses, purposes and biases. Included below are recommended texts, which are guided by questions:

NEW ORLEANS VOODOO

Q: Is Voodoo American culture?
A: Read Kodi Roberts's *Voodoo and Power: The Politics of Religion in New Orleans: 1881–1940* (2015).

Q: What are the three types of New Orleans Voodoo practitioners?
A: Unconscious, Afrocentric and Pagan. Refer to Christine Dickinson's thesis, "Aspects of Performativity in New Orleans Voodoo" (2015).

Q: What is the role of African songs in the possession experience?
A: Voodoo songs create a positive atmosphere for possession to occur and educate devotees about Marie Laveau, Papa Legba and the Lwas. See Jessie Gaston Mulira's chapter called "The Case of Voodoo in NOLA" in *Africanisms in American Culture* (1991).

Q: What are the Spiritualist Churches of New Orleans?
A: The Voodoo Spiritual Temple is a resource. Refer to Stephanie Bilinski's dissertation, "The Voodoo Spiritual Temple: A Case Study of New Orleans' Spiritual Churches" (2016).

VOODOO SPIRITUAL TEMPLE

To get to the Voodoo Spiritual Temple, one must leave the Quarter and drive to North Rampart Street. This healing center is located inside a recently painted Caribbean house. The downtown neighborhood contains brightly painted homes, used car lots and a Cajun food grocery store with a blinking OPEN light and a Po-Boy sign in the window. On the corner is Banksy-like graffiti art covered with plastic to protect the drawing: a young girl holding an umbrella in the rain.

On the door of the temple is a sign reminding visitors to enter reverently, quietly and with an intention. The temple encourages us to bring an openness to discover inner peace. Inside, an altar room provides a sacred space for meditation, consultations and rituals. Priestess Miriam Chamani provides readings, as well as education about West African spiritual traditions. (Refer to chapter 9, which contains a personal encounter with the priestess, where the conversation centered on Voodoo and God.)

The Voodoo Spiritual Healing Center is located in downtown New Orleans on Rampart Street. *Photo by Rory O'Neill Schmitt.*

Conclusion

Listen, see and feel Voodoo. Through visiting these special places in New Orleans, let's directly access Voodoo. These interactions invite deeper connections with Voodoo's material culture. The next chapter will explore Voodoo celebrations in New Orleans.

SPOTLIGHT INTERVIEW WITH DR. MARTHA WARD

Diverse perspectives sculpt a more holistic account of Voodoo in New Orleans. Dr. Martha Ward is an esteemed scholar on Marie Laveau. In 2004, she authored *Voodoo Queen: The Spirited Lives of Marie Laveau*. A retired anthropology professor from the University of New Orleans, Dr. Ward shared about Marie Laveau's descendants and how the women's religion of Voodoo provides agency and counsel.

Marie Laveau's Descendants

Today, many people claim to be related to Marie Laveau, often based on their common French name. Through her careful research of state records and archdiocese archives, Dr. Ward found that no direct descendants of Marie Laveau are alive today. Any actual descendants of Marie Laveau abdicated their heritage and fled the South during Reconstruction. As Reconstruction was an incredibly difficult time for many people of color, some individuals chose to claim their Caucasian heritage as their main ethnicity, relinquishing their African American identity. Struggling to endure amid persecution, individuals sought out means of economic and social survival.

Voodoo as an Evolving Women's Religion

Dr. Ward shared, "Voodoo is a women's kind of religion. It's women's spirituality." Voodoo has drawn support for women of all races. She explained, "It's always been mixed. There were never any white women against black women; [It was] women under the same things, regardless of color."

Voodoo exists as an evolving tradition. Dr. Ward stated, "Voodoo is still alive; it will always be alive. It always continuously changes, even by the week." When practitioners gain direct contact with the spirit world, they see Lwas and ancestors as reflective of their current Haitian, European or Spanish cultures. Voodoo adapts to meet the changing times.

Voodoo Offers Agency

According to Dr. Ward, Voodoo is "all matter of love, luck and the law." People seek out Voodoo to gain a sense of agency in a chaotic and troubling world. Voodoo helps people and relationships. She said:

You know, you want a divorce in a Catholic city? Voodoo.
Your husband needs a job? Voodoo.
You want him to be faithful? Voodoo.
You want him out of your life forever? Voodoo.

Through Voodoo, we find solutions.

Voodoo Provides Counseling

Dr. Ward said, "You know really what Voodoo does is often a form of counseling. And that counseling is really very good." She recommends calling Miriam Chamani for a reading. It was through an African bone reading with Priestess Miriam that she came to marry her husband. She explained:

> African bone reading is a very time-honored and excellent form of divination. And divination means to know the will of the Divine, whatever the will might be....
> "What do I need to know at this time in my life?"
> The spirits know your story. So, you go to a Diviner, who knows how to facilitate that contact in ways you don't know how, and to tell you what is otherwise unknowable—like the future.

For centuries, individuals have sought the counsel of local Voodoo priestesses. Through trance and possession, they interact with spirits to recover answers.

Closing

Key to understanding Voodoo is witnessing it as an evolving, sacred female spirituality. Exceptional are Dr. Martha Ward's expansive scholarship and her dedication to educating others.

VOODOO EVENTS

by Rory Schmitt

Celebrate NOLA!

As you know, in New Orleans, we celebrate anything and everything. We celebrate frogs, roaches, mosquitos, alligators, red beans and rice, gumbo, okra, corn, a headache, divorce, separation, and when your pregnancy test comes back negative."
—*Irma Thomas, singer of "I Done Got Over/Iko Iko/Hey Pocky Way"*

Like the Soul Queen of New Orleans sings, New Orleans loves to celebrate. In this chapter, let's explore how Voodoo practitioners commemorate life in ceremonies and community events.

The Original Voodoo Fest

Many have heard of Voodoo Fest, wherein fans listen to famous bands and singers, such as Kendrick Lamar and the Foo Fighters in 2017. However, fewer people are probably familiar with the original Voodoo Fest, which Priestess Brandi Kelly began in 1999.

Courageous, Brandi Kelly's mission is to support Voodoo practitioners in speaking for themselves. In her various roles as a New Orleans Voodoo practitioner, a Haitian-initiated Vodou priestess and business owner of Voodoo Authentica, Brandi has been an integral member of the New

The original New Orleans Voodoo Fest focuses on the cultural influences of Voodoo on the city of New Orleans. This photograph features local practitioners celebrating at this event in 2017. *Courtesy of Brandi Kelley.*

Orleans Voodoo community. Her focus is clarifying misconceptions about Voodoo and educating people of all ages what Voodoo in New Orleans really means.

With grace, Brandi serves as an educator and advisor to those who seek her out. New Orleans Voodoo is a complex combination of religious practices from different world cultures. Different practices coexist, and Brandi demonstrates this perspective by using expansive vocabulary that moves from one sacred practice to the next, describing African Orishas, Haitian Lwas and Catholic saints. When exploring Voodoo, she advises, "Take your time with studying this. There is a lot to learn."

Voodoo Fest centers on the spiritual practices, historic significance and cultural contributions of the Voodoo religion in New Orleans. Each Halloween, the event blocks off the 600 block of Dumaine Street outside Brandi's spiritual shop, Voodoo Authentica.

Voodoo Authentica is a local spiritual supply store in the French Quarter. *Photo by Rory O'Neill Schmitt.*

A big theme in the Voodoo community is taking care of one another. I learned from Brandi that your Voodoo family becomes your real family; they merge with your blood family. Her godmother, Mama Lola, and initiatory father, Jean Francois, travel to New Orleans for Voodoo Fest each year. Mama Lola's children and grandchildren (who live in New York and California) are Brandi's spiritual brothers and sisters. Together, Brandi's family cooks for days, feeding all those who come to the fest, including gumbo and "the best jambalaya you will eat in your life!"

Lectures serve as a way to educate newcomers and fight false information in patient and loving ways. Author of *The Mysterious Voodoo Queen, Marie Laveau: A Study of Powerful Female Leadership in Nineteenth-Century New Orleans,* Dr. Ina Fandrich draws crowds of contemporary scholars. Oftentimes, there tends to be a focus on the French cultural history of New Orleans; however, local priests and priestesses point out African and Haitian influences on New Orleans culture, as well. Musicians teach how rhythms and song lyrics are inspired by African spirituality.

Brandi Kelly leads an ancestral reverence ceremony in Congo Square in order to combat the stigma that Voodoo still faces. Openly practicing this sacred religion is a way to deconstruct misunderstandings. For years, Priestess Kelly has been leading this ceremony for the public to attend "so that we can come out of hiding. Now, people are emerging more and more."

DAY OF THE DEAD

All Saints' Day is in honor of Gede, a fierce protective spirit who opens the way and is probably St. Peter in syncretic terms. He wears purple or red. The All Saints ceremony is really spectacular, displaying fireworks and changing tones. At the end of it, the priestess blesses everyone.

On November 1, many Voodoo practitioners celebrate Day of the Dead, or Fet Ghede, as it's called in Haiti. They recognize ancestors and gain reassurance that the dead are never gone. At the New Orleans Healing Center event, some dress as skeletons or wear white clothing and purple headscarves or other festive ensembles. For instance, one older gentleman ported the Voodoo aesthetic, as he was dressed in all black clothing and donned a purple top hat. Individuals join for a potluck dinner and a second line parade, waving white handkerchiefs and dancing to the rhythms of a local brass band. La Source Ancienne leads a Vodou ceremony honoring Gede, the Lwa of sex and regeneration. Celebrants pay homage with offerings of flatbread, coffins, goat cheese and rum.

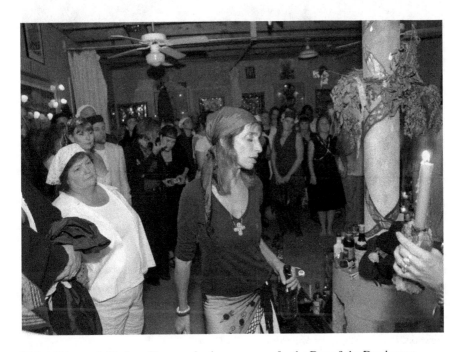

Vodou Priestess Sallie Ann Glassman leads a ceremony for the Day of the Dead event. *Courtesy of the New Orleans Healing Center.*

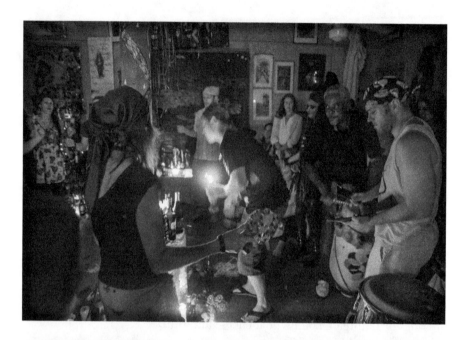

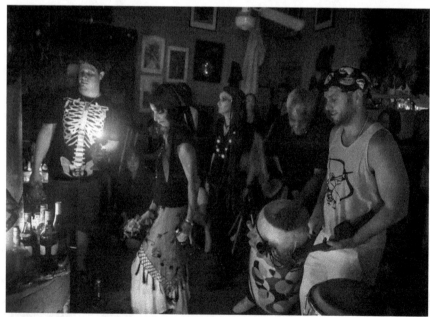

This page and opposite: A Vodou ceremony for the Day of the Dead includes sparkler fireworks. *Photos courtesy of the New Orleans Healing Center.*

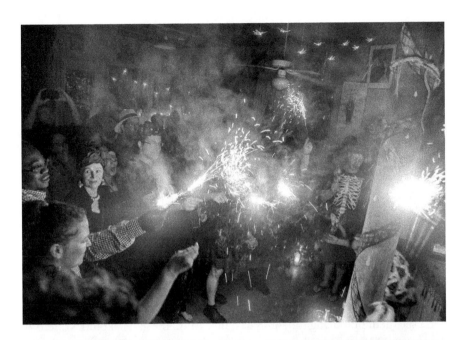

New Orleans Voodoo

The Bone Gang

At daybreak on Mardi Gras morning, the Bone Gang emerges from the cemetery. Dressed in black clothing painted skeleton-like, colorful bedazzled aprons decorated with skulls and sporting large papier-mâché skull masks, individuals walk the streets of the Ninth Ward, the French Quarter and the Marigny neighborhoods, reminding people that death comes for everyone. They admonish children to "Be good!"

After a recent trip to Zanzibar, Dr. Stephen Wehmeyer, an Afro-Caribbean scholar at Champlain College in Vermont, spoke with me about this group. He explained that the Skull and Bones Gang proves the connection between New Orleans and the Afro-Caribbean and Afro-Atlantic worlds. The gang is composed of individuals who are informed about the Afro-Atlantic world and well versed in the Haitian roots of their performance.

The Bone Gang is deeply engaged within community throughout the year, learning and teaching songs of these carnival community cultures. Outsiders don't see them practicing the songs or dances until the gang explodes out into the street at Mardi Gras. A living tradition, they celebrate the traditional part of New Orleans carnival, as well as African American carnival traditions. Their performances are profoundly embodied in the rhythms and songs, showing African connections. They access Spirit through the body and are world-embracing and body-embracing (rather than denying). Rhythm and dance are fundamental.

Wehmeyer recalled that carnivals stem from European Lenten ceremonies. When revelers go to the streets, it's the last blowout before a period of privation. There's no carnival in the world where you don't see images of dancing death; consider carnivals in Peru, Latin America or Venice, Italy. In New Orleans, they parade Bouf Gras, a massive fatted calf, as a symbol of abundance. However, the Bone Gang carries beef bones to recall the opposite of that abundance and remind viewers of the bones underneath the flesh. They point to a period of privation before spring arrives.

Wehmeyer shared that you can lecture on cycles of life and death and human mortality, but people will fall asleep. However, when members of the Bone Gang dress as skeletons and dance in the street, the group safely relays deep messages. If it's interesting and intriguing, more of the messages get through. For example, if a Bone Gang member stops traffic and points a bone at a Lexus driver and then lectures him on living morally right, the driver will listen. He might be thinking it's only Mardi Gras, it's in good

humor, and it only happens once a year. However, we break the rules once a year to remind us why we make the rules in the first place.

The visual culture of the Bone Gang resonates with Haitian Vodou. Performances as skeletons are associated with Gede. Skulls on their aprons point to Masonic connections. Wehmeyer explained that Freemasonry images and icons formed a significant part of Haitian religious culture. French colonizers didn't only bring Catholicism when they brought enslaved laborers to Haiti; they also brought French Freemasonry. Death imagery is associated with these fraternal orders, like Freemasons.

Mardi Gras is deep play and reveals the most powerful motivations of our societies, which are often veiled in expressions of humor, pleasure and entertainment. Perhaps you can tell more about a society by looking at the way it plays than when it acts seriously.

Mardi Gras Indians Celebrations

If you've ever been to New Orleans Jazz and Heritage Festival or participated in Mardi Gras, you have probably seen Mardi Gras Indians marching in parades, celebrating alongside brass bands and gracefully interacting with the community on public streets. Dressed in ornate suits of vibrant colors, they display intricate beadwork with symbolic imagery often on their chests. Giant colorful feather headdresses dramatically frame their faces.

When speaking with a local anthropologist, I learned that Mardi Gras Indians are not necessarily practitioners of Voodoo, but they are related to Voodoo in their public performances and street rituals. Dr. Ward stated, "The spiritual descendants of [Marie] Laveau's are probably the Mardi Gras Indians." Their special handcrafted spiritual suits are akin to "walking altars."

One Mardi Gras Indian, Janet "Sula Spirit" Evans, serves as queen of the Mandingo Warrior tribe, the Spirit of Fi yi yi. The tribe consists of members of the African American community. She explained that the cultural practice is deeply ancestral. Since Mardi Gras Indian suits are often misconceived, many tribal members feel protective over the information.

Sula Spirit shared that each sacred suit is created in devotion to a special person, intention, spirit or Orishas. Outsiders may not know that the member sewed Orishas' power or an ancestor's Ashé (spirit) into the suit. They may not know that a suit could be "dedicated to their mother who passed away, or their little baby who died." Sula Spirit's sacred suits resonate

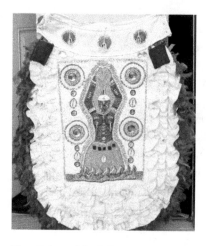

New Orleans Mardi Gras Indians' sacred suits include intricate beadwork to create powerfully distinct forms. *Photo by Rory O'Neill Schmitt.*

the power of the Holy Mother: Yemaya (the Salt Water Mother), Mami Waters (a priest whom she was initiated under in Ghana), Oshun (the deity associated with water, love and fertility) and Bayanni (the Sweet Water Mother).

Being able to sew and do beadwork are requisite to being a Mardi Gras Indian. Beadwork for sacred suits is done in private; makers can devote a year to a work. When guests visit her home, Sula Spirit turns over the beadwork on a panel and reminds them that others aren't supposed to view the suit or talk about it until the special celebration day, such as Mardi Gras day, St. Joseph's Night or Super Sunday. She explained, "We're on Milneberg, only in the 'hood. If you're not in a black neighborhood, you're not a Mardi Gras Indian."

Sacred suits serve spiritual functions, as individuals embody their beliefs through their suits, as well as through public performances of music and dance. Sula Spirit said, "People come and bless the streets with all kind of spiritual symbols and empowerment—things around who we are as African people and people of color."

The meaning of Sula Spirit's sacred suits is informed by her Spiritualist beliefs, diverse religious knowledge and relationship with Vodun (Spirit), the Orishas and ancestors.

ST. JOHN'S EVE

Perhaps the most widely known New Orleans Voodoo event is the Eve of the Feast of St. John on June 24. The feast date is based on the birthday of John, who was born six months before Christ. Roots of St. John's Eve celebrations travel back to 1719. From the 1830s to the 1870s, Marie Laveau led celebrations and conducted ceremonies at night, hidden from view in an isolated part of the bayou, as the city council had enacted a law that prevented residents of color from gathering in groups. This event regularly attracted journalists and curiosity seekers. Some say that Marie

Laveau invited them to a decoy, as the real ceremony took place farther into the city, past the Carondelet Canal, congregants sang hymns of devotion, made offerings, danced and drummed. Voodoo practitioners believe that this is the day that the veil between the spiritual world and physical world is nearly nonexistent, enabling communion with ancestors, Lwas and Spirit. It is also the time of midsummer and summer solstice, the longest day of the year.

I spoke with local priestesses who annually lead St. John's Eve celebrations in Congo Square, on Bayou St. John and in the French Quarter. On Magnolia Bridge over the bayou, La Source Ancienne Ounfu invites the public to wear all-white clothing and headscarves and bring offerings to Marie Laveau. (An additional beautiful event associated with St. John's Eve occurs indoors at the International Hotel.)

On Marie's altar, they place Creole dishes, barrettes, ribbons and hair tools, blue and white candles and flowers. Songs, dances and spiritual drumming drive the rhythm of the event. During the ceremony, participants may experience the traditional head-washing purification ritual, called *lavé tete*. This ritual is similar to a Vodou baptism and is the precursor to being initiated into the religion. The Lwas reside in the head, and when purifying the hair, one makes a consecrated temple for the Lwas. Attendants can have their hair washed. Afterward, they apply a potion, composed of coconut cake, Florida water, eggs and other symbolic items. Congregants are told to let it dry on their hair for the night and record their dreams. Dreamwork may provide opportunities for important messages from ancestors to be shared.

SEASONAL CEREMONIES

Similar to many world religions, Voodoo follows a cyclical nature, which includes sacred days with associated ceremonies. Festive messages repeat, creating feelings of trust and safety, igniting inspiration and inviting jubilation. When Voodoo practitioners celebrate together, they develop a deep-rootedness in the community that spawns healing and empowerment.

For instance, around Christmastime, practitioners at Archade Meadows hold a Petro ceremony with bonfires, flaming baths and magic. They call out for transformation and revolution. Around Easter, individuals celebrate the Rada spirits with the Manje Lwa Rada ceremony and a Retire D'anba Dlo Rara parade. Priestess Glassman told me, "On Easter, we feed all the general

Rada spirits. They're sleeping all through Lent. So we wake them up with a big feast, singing and dancing on Easter."

In July, at the hurricane-turning festival, community members dress in red (the color of fiery Petro) and white (the color of purity) and petition Erzuli Danto and Our Lady to intervene, bringing them offerings of rum, daggers and fried pork, as well as religious pictures, jewelry and flowers, respectively. Erzuli Danto enjoys storms and mayhem; however, when she feels recognized for her power, she will divert a storm's fury. If unable to attend this ceremony, individuals can create a personal ritual, which involves making a shrine by draping a tabletop with white cloth and displaying a Virgin Mary picture. A personal ritual helps to establish intimacy with the Spirit and make a connection to power.

The third week in July brings the Hurricane-Turning Ceremony. This intense ceremony focuses on serious illness and terminal cancer; it's about life and death, slavery, freedom.

The Hurricane-Turning Ceremony is under a very fierce spirit of unwed motherhood, Caribbean and ocean travelers and winds. This very fierce spirit (sometimes called Erzulie) is also known as Our Lady of Prompt Succor, and she protects New Orleans. She's the saint the Ursulines prayed to years ago to save the city first from a devastating fire in the French Quarter in 1812 and then from the British forces in the Battle of New Orleans in 1815. (New Orleanians are said to have joined nuns in their chapel to pray while bullets flew.)

The Ursulines have a ceremony to Our Lady on June 1, while Voodoo practitioners have theirs, usually on the third Saturday of July. It's beautiful. It's the one you can wear red to. It makes New Orleanians feel so good, like *thank goodness we made it another year.*

Local practitioners pray together with candles at a cemetery. *Courtesy of the New Orleans Healing Center.*

Lastly, throughout the year, individuals participate in crime prevention ceremonies. Walking down the streets of the Bywater or strolling through a cemetery at night, you might see individuals dressed in white clothing with red headscarves, holding red candles. Bringing offerings of rum, cigars and images of the warriors St. James Major and St. Michael, they petition the urban Lwa Ogou Achade, who is committed to protecting the family. This ritual removes negative energies contributing to greed, violence and pain.

CLOSING

This chapter shared sacred meanings associated with Voodoo ceremonies and community happenings in New Orleans. The next chapter offers an invitation to know two local religious leaders.

NEW ORLEANS RELIGIOUS LEADERS: THEIR LIVES AND THEIR ART

by Rory Schmitt

In this chapter, let's explore how two religious leaders embody their beliefs through their art and their service.

Janet "Sula Spirit" Evans

I feel blessed to have had the opportunity to speak with an ordained priestess, Janet "Sula Spirit" Evans, Nana Sula (*nana* means priestess in Ghana). Her wisdom and advice helped to both guide and expand my understanding of West African–based spiritual practices in New Orleans.

Finding Vodun

I asked Nana Sula Spirit, "How did you come to find Spirit? How did you come to find Vodun?" She shared her spiritual path.

Between the ages of twelve and fourteen, the doorway to her journey began with the Born Again Christian tradition in New Jersey. From ages fifteen to nineteen, she was drawn to African religions as well. She explained that she was naturally very curious about the many bloodlines that run into her. At age nineteen, she had a powerful spiritual experience when her boyfriend, Martin Salinas, invited her to a Mesa, a Santeria tradition of honoring and channeling ancestors and bringing messages to the living. Here, she witnessed Spirit possession for the first time.

Shortly after the Mesa, Marty passed away, and Nana Sula Spirit found healing through listening to African chants of the Orisha. She shared, "The music became a really powerful vehicle for connecting to the ancestors and to the Spirit." Between the ages of nineteen and twenty-four, she delved further into exploring African spirituality through the Yoruba and Akan traditions. During her twenties, she earned her bachelor's degree from Rutgers University in African studies and English literature.

At age twenty-four, Nana Sula Spirit joined the Egbe of Orisha, a Yoruba/Ifa Spiritual house in New York led by Baba Ade Olayinka and Iya Omifunke Marilyn Torres (her first godparents). She dove into the Yoruba/Ifa Orisha tradition, as well as studies of the Ewe tradition of Togo, Benin and Ghana. Her maternal great-great-grandmother, she learned, was from the Ewe tribe.

In West Africa, the Yoruba peoples are a large, diverse ethnic group, primarily in Nigeria, Benin, and Togo who share a common language, history and culture. Africans brought their religion with them during the transatlantic slave trade from the 17th to 19th centuries. The Ifa religion constitutes traditional spiritual practices of the Yoruba peoples. The initiated priests are called Babalawos. In this religion, there is one supreme deity (Olodumare) and 100's to 1,000's of minor deities or Orisha.

A part of Nana Sula's development as a priestess has been to immerse herself in studying world religions, enabling her to be versatile in counseling individuals. For two decades, she has practiced Hindu teachings with a monastic community, called Veil of Truth (the Purple People). Nana Sula Spirit told me, "The mark of any priestess is to be well versed in many traditions because as a priestess, you're going to have people come to you that might have come from a church, or might have come from a mosque, or might have come from a Spiritualist tradition, or might come from a space where they don't believe at all. So, it's beautiful to be well versed in several traditions."

Spiritual Work in Louisiana and West Africa

In 1996, Nana Sula Spirit moved to New Orleans to trace her ancestors' lineage, study with Miriam at the Voodoo Spiritual Temple and learn more about Marie Laveau and her ancestor Marie Therese Coin-Coin. She was inspired by the book *The Forgotten People: The Creoles of Color from Cane River, Louisiana* (1977) and was moved by the spirit of her great-great-grandmother

Marie Therese Coin-Coin, who was born in 1742 in Natchitoches, Louisiana. *The Forgotten People* linguistically traced Grandmother Coin-Coin back to the Ewe tribe in West Africa. The name Coin-Coin is closely related to Koi-Koi (Kokwe), meaning the second-born female child in the Ewe tribe. Through learning about her ancestry, Nana Sula Spirit was pulled to deeply study West African religion, Vodun, Ewe and others. At age twenty-four, she was led to join a spiritual house in Ghana called the Shrine of Impohema, where she met her godparents in the Akan/Ewe tradition. In 2007, she was initiated in Ghana under the Ewe Vodun system and became an Ewe priestess with the gift of channeling ancestors.

The key to her spirituality is the role of the ancestors whose legacy must never be forgotten. Nana Sula Janet stated, "If you don't talk about them, who will ever know they were here? We must always keep their memory alive. We pay homage to our ancestors out of love, respect, and gratitude."

Nana Sula Spirit shared that Vodun and other spiritual traditions invite others to feel empowered, not scared. You feel the light of the ancestors' rituals and ceremonies. Speaking the names of the Orisha/spirits calls up energy and power. "There's Ashé [life force] and power in the names." She explained, "Everything is living and made of living energy or life force. Everything has Ashé. So that particular Ashé is really the medicine in this work, as we combine the calling in of God, the Father and Mother of Creation, the elemental forces and the power of our ancestors. That is what brings power to the prayers and brings power to the ceremonies and brings power to the work."

Nana Sula Spirit pointed out that a common misconception persists that all forms of Vodun are identical. She emphasized that Haitian Vodou and West African Ewe Vodon are distinct, each religion having different practices, spiritual names and deities.

Spirit of the Orishas

In the Yoruba religion, everyone is created by God and assigned a guardian spirit. The Orishas are spirit guides that lead us to our higher selves, protect us, and remind us of our ancient lineage. As head guardians, Orishas serve as intermediaries between the Supreme God and humanity. Elements of this belief system can be found all over the world: in Puerto Rico as Santeria; in Brazil as Candomblé; in Haiti as Vodou or Vodun; and in the Americas as Yoruba, or all of the above.

Nana Sula Spirit travels all over the world teaching Orisha chants. And in 2014, she published her book, *Spirit of the Orisha,* and produced a CD of thirty-eight Orisha chants at the Ellis Marsalis Center for Music with her sisters from the Zion Trinity band. Traditional Orisha chants are often sung in Bembes, which are spiritual gatherings with two-headed ceremonial Batá drums. These songs can be heard in popular Orisha, Santeria and Ifa ceremonies to bring healing. Ancestors carried the Orisha music throughout the Diaspora in their souls, overcoming oppressive forces. These sacred chants combat negative energy and lead us to freedom, liberation and spiritual elevation.

The book includes chants in Yoruba with English translations and phonetic pronunciations. Sula worked hand in hand with native Yoruba translator Omoba Adéwálé Adénlé. Sula Spirit created the accompanying artwork in the book, as well. Ochosi, the Orisha of Hunt, is depicted with a pen-and-ink drawing of a bow and arrow. His warrior chant includes the verse: "Iban nla ode fa (E bahn la oh day fa)," which translates to "Great homage for the hunter with an arrow." Sula Spirit shares information about each Orisha, including their preferred colors (Ochosi's are blue and orange), numbers (3 and 7) and specialties (his expansive knowledge of Shamanism and herbs, his commitment to justice and his place as patron saint of animals).

The Temple of Light, Ilé de Coin-Coin

Combing the literature of library databases can bring us closer to the truths of others' perspectives. We learn through exploring carefully curated information. However, through encountering human beings in person, visiting their sacrosanct homes and seeing their work firsthand, we are able to more deeply know and more gracefully understand. Following is the narrative of my meeting Nana Sula Spirit in person for the first time at her residence in the Ninth Ward, a revitalized neighborhood of brightly colored Louisiana-style cottages, once blighted by Hurricane Katrina.

I climbed the front steps of her raised cottage and knew I was in the right place: bold, hand-painted wooden signs referred to the Orishas and instructed visitors to please remove their shoes. After all, homes are sacred spaces. Sula Spirit greeted me at the front door and kindly asked me to wait on the porch while she finished up a call. Seated on a bench, I spent a few moments breathing in the scene:

- Plants, bursting with green colors, enveloped the porch. Over a dozen potted plants and herbs decorated the bannisters, steps and floor. She shared with me that some of her herbs are used for healing, spiritual baths or rituals, while others are just to give nourishment.
- A statue of the Black Madonna/Mother Mary with open arms stood on the grass, blessing the house. New Orleans yards are frequently adorned with Catholic religious statues, offering a reminder of spiritual protection, as well as inspiring courage to believe.
- An enormous palm tree with a thick trunk stood central in her front yard. Sula Spirit explained that the palm tree was planted in honor of the Orisha Ogun, Warrior and Protector. When she bought the house, she planted this palm tree and petitioned Ogun for protection. Ogun likes rum; therefore, she pours offerings to him. Behind the palm tree, I spotted empty bottles of rum—libations for Ogun.
- Directly across the street is the Ellis Marsalis Center for Music, founded by famous local jazz musicians Harry Connick Jr. and Branford Marsalis. It is a school of music for children and a performance community space for musicians. After Hurricane Katrina, the center was erected to encourage musicians to come back home. Partnering with Habitat for Humanity, Harry and Branford, and other members of the community, organized to create a village for musicians and an opportunity for musicians to own their own homes. Music remains the root, the soul and the identity of this city. Local music tells the story of the Crescent City through lyrics and beats. Later, I heard brass music being played by somebody nearby in the neighborhood. Music lives in the air of New Orleans.

In this short scene, I was able to make connections between spiritual practices, New Orleans and Voodoo/Vodun. As Voodoo/Vodun practitioners incorporate a veneration of Earth in their rituals, some Spiritualists also acknowledge the power of the sacred Mother/Mother Nature. Herbs are seen as deeply healing. In addition, I noticed that an inclusion of Catholic iconography recalls that Voodoo is also a syncretic religion. Often, believers subscribe to multiple traditions. Lastly, I recognized that music is deeply tied into cultural and religious traditions. As Orisha chants bring the body

healing, jazz music helps heal New Orleans. The music has helped the city move past the hurricane devastation.

I was awakened from my daydreaming on the porch by Chester, Sula Spirit's large lab mix dog, who greeted me. Sula Spirit reminded me of the importance of totem animals. Animals want to protect us. They can sense things that humans don't notice. Therefore, we must be kind to animals and pay close attention to their warning. In Haitian Vodun, they call the Orishas or Spirits "Lwa"; in the Akan Ewe, they call them Abusom/Obusun.

Sula Spirit next invited me to her shrine, which was located in the backyard. Following behind her through the side yard, she waved her hand over herself and said a prayer. She asked the spirits to not let anyone with bad intention cross the threshold of her yard. She knows the ancestors and Spirit intimately and trusts them to protect her.

Entering through a chain-link fence, I saw a spiritual painting on the ground, marking the entryway of a new sacred space. In the quaint backyard with a raised garden bed, filled with lavender, we sat on the two chairs on the grass. I could hear music and kids playing in the backyard two doors down and could see people walking through the neighborhood. We shared a moment to connect.

Sula Spirit next walked over to the shrine, an older wooden shed whose exterior had been painted white. She unlocked the padlock, opened the double doors, lifted the delicate black-and-white patterned African tapestry and stepped inside. Still seated about twenty feet away from the shrine, I heard her sing a song and pray. She had a lovely voice. I remembered she was a musician.

Sula Spirit then cleansed me with frankincense. I admit I was a bit nervous. *Trust.* I realized I had to trust her and trust this process, so I closed my eyes. I was there to learn. Using the smoke of frankincense and myrrh, she was performing an energy clearing and advised me to hold out my arms like a T. Waving the smoke around my aura, she said some prayers to God and the ancestors. I could smell the strong ancient scent wafting toward me and feel the warmth of the fire.

Before entering a shrine, everyone must be smoked. In Ghana, you have to actually take a spiritual bath before you go into a shrine. I learned that it is best not to have your shrine in your home for spiritual cleansings. It must happen outside the home, as you don't want to keep that kind of energy around.

She then allowed me to view inside the opened doors of the shrine:

- My eyes surveyed the interior perimeter of the room. I noticed writing done in cursive print on the walls. I saw blessings like, "Help me to be a good sister," as well as positive messages of peace, love and protection. This space was a humble sanctuary. It was freeing; one could write on the walls. Making one's mark on a wall has been an act of humans for millennia. Changing one's space by marking a word or a symbol is empowering and cements a particular time in history. This connects to New Orleans Voodoo spirituality. One can speak directly to the Orisha and God, asking for guidance and strength.
- Located centrally in the shrine is an ancestor altar. A long table about eight inches off the floor, it held a tall wooden African sculpture. There were also several framed pictures, including those of her Ghanaian husband and her godfather who had initiated her in Ghana. The altar held artifacts showing her connection to West African culture, art and aesthetics.
- Small woven rugs covered the floor, adding warmth and comfort to the space. There was a kneeling bench, indicating the purpose of prayer. I thought to myself: *This is where the prayers are done, in a small shed out in the back of her house.* I learned the functionality of the shrine: a comfortable, quiet space, free from distraction and devoted to meditation, prayer and connection with the ancestors and the Divine.

A paradigm shift of my conception of a temple occurred through visiting the Temple of Ilé de Coin-Coin. Going there, I expected a shrine, perhaps kind of like a Catholic church or a Buddhist temple. I knew that Sula Spirit had vast experiences with different faith communities. Was I expecting a tall, gold-encrusted temple? The shrine was very simple, very humble. She told me the shed in her backyard is like Ghanaian temples that people often have in their yards on their property. This was where the spiritual work was done. She told me that she always had the shed; she just changed it into a temple. People can adapt their current spaces to serve spiritual purposes. Perhaps we don't need gigantic cathedrals to meet God.

The shrine is where she performs her readings and consultations as a full-time spiritual worker. When individuals come to her asking for a spiritual reading, she only asks them their first name. They ask her, "You don't want to know my last name?" She responds, "No. I don't know you. The ancestors—my ancestors and your ancestors—will tell me all I need to know." With

the help of her grandmother Coin-Coin, a possession experience enables her to receive messages from the ancestors. Sula Spirit sees her body as a vessel, where she explains, "I'm emptied out, and she's poured in." After the reading, they do a cleansing with a gallon of water. And they pour gin as a libation offering for the Orisha.

Next, we left the temple and the backyard and moved to the front of the home. When we were leaving the shrine area, going in the side yard to the front yard, I was very careful to try to be respectful and follow her lead. I asked, "Is it okay if I take your picture? I didn't know if it was okay if I took some pictures out here. Would you prefer I didn't?" She invited me to take a few pictures from the fence of the shrine area.

We moved to the front of the house, which is where I was able to take her portrait. It was magic hour, that time when the sun is just beginning to set, when the rose colors of the sky reflect from the clouds, making the green shades of grass punch vivid hues. Sula Spirit was cloaked in a textured, thick white garment with blue stripes. A thin white muslin fabric enwrapped her head, and bangs of dreadlocks poked out. Big, artistic white cat eyeglasses framed her smiling face. She beamed with pride and grace.

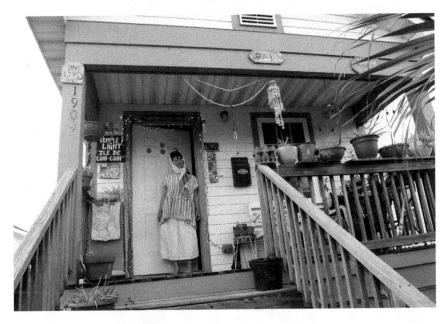

A portrait of Sula Spirit outside her home in the Ninth Ward. *Photo by Rory O'Neill Schmitt.*

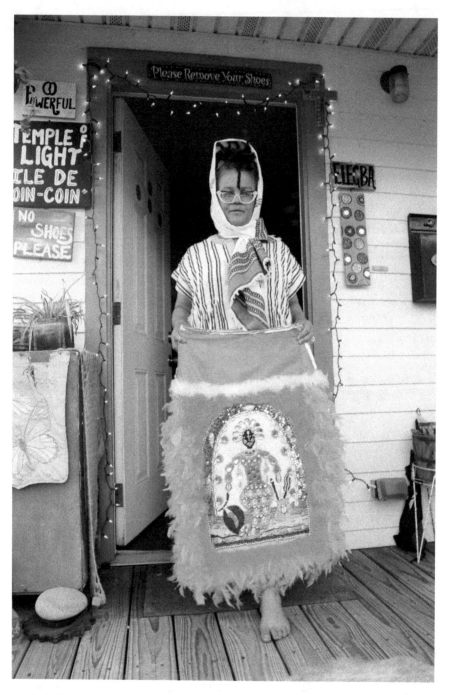

A Mardi Gras Indian and leader, Sula Spirit displays the sacred suit that she sewed. *Photo by Rory O'Neill Schmitt.*

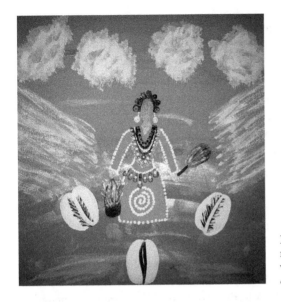

Folk artwork by Sula Spirit may reference the Divine Feminine, as well as nature. *Photo by Rory O'Neill Schmitt.*

For a moment, she went indoors and then brought out her Mardi Gras Indian suit. She stood and held the sacred suit and the crown (head covering); the hot pink colors and bold feathers were exciting. On the front of the suit was a picture of a female figure. Sula Spirit spoke to me about two female Orishas, representing powerful feminine energy and creative life force. I considered that putting on the sacred suit connects to the performativity of Voodoo and Spiritualist practices. One becomes someone else, represents someone, a spirit larger than life, and shares a powerful message. While cloaked, one is free on the streets to dance and celebrate with one's tribe, whom one intimately knows.

Next, she invited me inside her home, and I felt like the trust was building. To the right of the entrance was a table with items she sells at the local St. Roch market each month: myrrh, frankincense, sage, oils and incense, as well as her spiritual sign paintings.

Circling around the room, I recognized a large colorful folk art painting from the cover of her book, *Spirit of the Orisha*. It depicted three women with arms raised above their heads; one held a shield that read Egun. Egun are the ancestor spirits who assist us and protect us from danger. Underneath the painting was an altar filled with many framed pictures.

Snaking over to the next side of the rectangular room, I saw the entire wall was filled with framed photographs. On the top part of the wall were photos of living relatives and friends. Centrally located was a 3-D life-sized wooden sculpture from New Guinea depicting a pregnant torso and bust. (I

remembered that Sula Spirit has been a birth doula for over a decade.) This artwork served as a divider for the bottom half of the wall of photographs: images of those who had passed.

The fourth side of the room had tables with framed photos of more ancestors, including her grandparents and relatives from Cane River. The most recent person who entered the sacred heavenly village was her first client to pass, a young African American man who was murdered. I learned from Sula Spirit that you're not ever supposed to put living people on your ancestor altars. It's important to keep these separate.

Spiritual Community

Every month, Sula Spirit leads a new moon gathering at her shrine. With visitors, she discusses what the new moon brings. The new moon event that month for Sagittarius focused on letting go. She said we must let negative things die, allow them to be killed if they're not serving us anymore. The group meditates together, and after thirty minutes, she rings a gong. Then the group joins for a meal of vegan lentil soup. Sula Spirit stated, "I'm trying, I'm attempting—No, I am. I'm forming community."

The community recognizes the value of the Earth and the cycles of the moon; they discover deeper meanings relevant to their own lives. Together, they take the time to meditate, express themselves and receive nourishment together. I found values here to be connected to other New Orleans Voodoo elements: Earth worship, openness to Spirit and a community feast.

For many, meditation can be challenging. She calmly explained, "Well, that's because it's all about the breath." And then she stopped, closed her eyes, took a long deep breath in and took a long breath out. She said, "Sometimes in meditation, people tell themselves, 'Breathe in, 1 2 3, Breathe out 1 2 3.' That's not quieting the mind. When you're still conscious like that, your mind is still chattering. That's not the way to meditate."

She stated, "Meditation is listening and letting go. It's just listening. Prayer is talking to God, asking for things, thanking God, speaking to God and making petitions, but meditation is just about being quiet and listening to what spirits have to say." Meditation requires individuals to release consciousness.

Sula Spirit devotes her life to helping people in the community. At fifty-two years old, she feels grateful to be able to wake up every day and do this work. Sula Spirit intimately knows and trusts the Orishas. She believes that people come into your life for different purposes. For instance, her ancestors

knew who I was and told her that some greater force was happening to bring me to her. Perhaps I gained some bravery in entering a new territory and remaining open to learning. Sula Spirit called me to consider: *Maybe I wasn't alone in this world?* Larger spirits and ancestors are at work, breathing meaning and purpose to every event.

SALLIE ANN GLASSMAN

A key Vodou leader and visual artist, Sallie Ann Glassman is a committed community member. Often interviewed on news stations and in documentaries, she distinguishes real religious practice from false Hollywood depictions.

Finding Vodou

Sallie Ann was raised in the Jewish faith in Maine. As an adult, she followed a calling to move to New Orleans. Soon after, she began practicing Vodou. She said, "I was always very aware of an invisible interior world, and when I came to New Orleans and started actually being around some Vodou practitioners, I realized that they saw it in the same way."

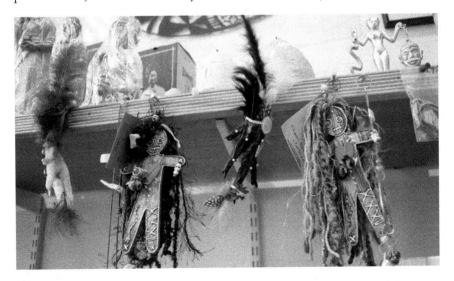

Sallie Ann Glassman is the business owner of the Island of Salvation Botanica, a spiritual supply store where chicken foot fetishes, as well as other religious objects, are available. *Photo by Rory O'Neill Schmitt.*

Her path led her to priestess initiation in Haiti. She shared, "I was initially intending just to go to [Haiti] to witness a ceremony there. While I was talking with a friend who lived in my neighborhood and who was sponsoring a temple that year in Haiti, the phone rang." It was the priest Edgar Jean Lee, and he told her that he had consulted with Spirit and it was time for her initiation.

Over the years, Sallie Ann and Edgar developed a strong bond. She said, "He called me his daughter, and I called him my papa. We went back and forth; he would come here and work with us in my house and stay with me. And I would go there and stay in his temple and work with the people there. So, it was just a profound, life-changing encounter. And I stayed with it."

Later, Sallie Ann shared with me that sometimes Père Edgar reflected discomfort in visiting New Orleans because he would see so many spirits moving about the city. She told me that those who can see spirits often encounter several. Spirits may be drawn to these individuals because they yearn to be recognized. Sallie Ann asked, "How would you feel if you could never be seen?" She helps others to see the humanity of the dead. Vodou aims at decreasing fear and demystifying death.

Religious Leadership

As advisors for the community, priestesses provide healthy counsel. Sallie Ann said, "I think for people who are initiated into the religion, mambos and oungans, there's a range of abilities that come to play. So you have to be somewhat psychologically astute to be able to give people advice and work with people....A lot of priests have the ability to go into trance and carry Spirit, or do psychic readings."

As both women and men carry the baton of priestesses and priests in Vodou, no gender hierarchy prevails. When I spoke with a world religion scholar, Julye Bidmore, I learned that women lead New Orleans Voodoo because it is a healing religion, and females have often been associated with the healing arts. Their nurturing role invites opportunities for women to hold seats of power. Perhaps having a woman religious leader holds symbolic weight. Embracing a woman leader may show that practitioners are perhaps more evolved in their concept of leadership. In addition, a female religious leader may support believers in their subscription to both the masculine and feminine aspects of the Divine.

A portrait of Priestess Sallie Ann Glassman in her Archade Meadows Vodou temple in the Bywater neighborhood. *Photo by Rory O'Neill Schmitt.*

The Healing Arts of Vodou

Sallie Ann stated, "Vodou—contrary to popular opinion—it's not about hexing people. It's about healing. And healing is understood as finding balance and combining and balancing all of these different forces." Through rituals, practitioners can re-empower; they can heal themselves spiritually. During Vodou ceremonies, the arts provide evocative power. Sallie Ann said, "Certainly Vodou is nothing if not visual in every way. It's music, it's art, it's dance forms. Its ritual gestures are very gripping and very affecting. The various spirits have such strong, archetypal personalities and presence within nature."

Art-Making Methods

Even as a child, Sallie Ann was drawn to make art. She shared, "I always liked to create art. I didn't have really any training in it. When I was a little kid, we used to go on Saturdays with my dad to a friend's house who was an art teacher. We were allowed to play with any materials that we wanted. It was a great experience. And encouraged me to play with art."

When she moved to New Orleans, Sallie Ann attended the New Orleans Art Institute for formal art training. During this time, she developed as an artist, both her technique and her dedication to the vocation. She said, "It did get me into the habit of painting, doing art every day and spending a number of hours every day working." To this day, she disciplines herself by blocking out a specific day each week to focus on making her art.

Whether it is painting in her studio or doing crafts in her spiritual supply shop, Sallie Ann finds deep meaning in making art. She shared, "I just love it. It gives me a great sense of peace and purpose, and that's the only time in my life when I'm not concerned that I should be doing something else. You know, it just takes over, and I get to be in the creative process. So it's like being in the zone, I guess you could say." While creating art, she feels the exuberance of creativity.

Sallie Ann paints Divine energy that she sees in nature. She said, "I've always seen nature as animated and having a numinous quality. It's more than just a tree that you're looking at. The blade of grass has energy and life force in it and intelligence. So I've always painted from that perspective. Vodou kind of gave me an imagery to work with, a vocabulary." She described her art-making process: "I just sort of paint from the heart.... There's a degree of automatic quality to it. It does feel like I'm going into a trance at some point when I'm painting. Whatever Spirit wants to express just comes through."

Reflecting on Sallie Ann's automatic art process enables one to note a connection between Voodoo art-making processes and twentieth-century art movements and philosophies. For instance, Surrealist artists became fully absorbed in art-making by freely drawing, painting or sculpting without concern for the end product. In 1924, André Breton believed that the unconscious must be liberated. The larger reality, or "surreality," rests beyond a narrow, rational notion of reality.

Unleashing the unconscious through art and symbols was a theme of Carl Jung's, as well. The theory of the collective unconscious states that underneath one's private memories exists a storehouse of feelings and symbolic associations shared by all humans. Voodoo employed the subconscious mind centuries before this theory. New Orleans Oshun priestess Luisah Teish writes, "Our ancestors had access to the collective unconscious centuries before Jung's mother got pregnant." Through exploring the unconscious, Voodoo practitioners and artists unleash universal themes.

In my own art-making process, I've found that once you step back and look at your artwork, you can discover the concerns of your unconscious.

Art is the soul's mirror. It forces you to see what sometimes you don't want to deal with, what is sunk deeply below muddied waters and rises like a corpse, bobbing on the water's surface. It is up to you to shake hands with that work and identify yourself.

Traditionally, elements that shape an artist's style include color, subject matter, line quality, perspective and the tendency for realism or abstraction. Viewers identify the similarities in these elements and then attribute an artwork to a specific artist, as the artworks reflect a family resemblance. However, Sallie Ann's process of being open to the artwork that emerges invites opportunities for her to create artworks that are varied in style and subject matter.

In her temple was a colorful painting of heavy metal rock stars, with faces painted like the band KISS, hanging above a larger dark painting of a murky swamp depicting a Haitian myth. Nearby was an intricate painting of Mecca. Working from a photograph, Sallie Ann created an aerial perspective of this sacred religious space. Within the four walls of the site, dots represent

This painting of Mecca by Priestess Sallie Ann Glassman recalls world religions, diverse spiritual paths and sacred pilgrimages. *Photo by Rory O'Neill Schmitt.*

several figures rhythmically arranged (or "manically," as she described the process to me). It appeared that several artists, rather than a single author, created the artworks in her temple. However, Sallie Ann shared that actually, this had been a challenge for her. Art galleries were reticent to represent her because she wasn't limited to a single style.

The Snake as a Sacred Symbol

Did you know that forty-six species of snakes live in Louisiana? These include the diamond-backed water snake, flat-headed snake, harlequin coral snake, pygmy rattlesnake and coachwhip. Snakes are incorporated in the Voodoo religion, an Earth-centered spirituality. For centuries, New Orleans Voodoo rituals have employed snakes. Voodoo invites you to embrace all forms of nature and animal life. Rather than run away from snakes, New Orleans Voodoo calls you to dance with them.

Today, local Voodoo temples may incorporate snakes in ceremonies. The Grande Zombie is the Temple Snake, which performed ritual functions at the New Orleans Voodoo Spiritual Temple. Ava Kay Jones, a Voodoo and Yoruba priestess, became famous for removing the Superdome curse when she incorporated her boa constrictor in a public ritual before the game, where she danced with the snake draped around her neck. Locals give her credit for the Saints' first playoff victory in 2000.

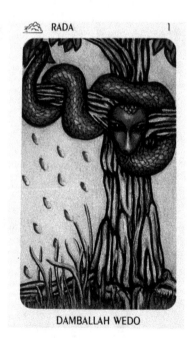

DAMBALLAH WEDO

Voodoo practitioners believe the snake holds intuitive knowledge. The snake may also represent the umbilical cord, connecting mother and child. A snake reminds us of how we are linked to both the past and future—our ancestors and our descendants. In Vodou, the snake represents Damballah, the Great Servant, who links practitioners with ancestors' power and wisdom. The snake reflects divine wisdom that should not be feared.

The New Orleans Voodoo tarot card, *Damballah Wedo*, features a red snake enwrapping a tree. *Artwork by Priestess Sallie Ann Glassman.*

0

WORLD EGG

PETRO 1

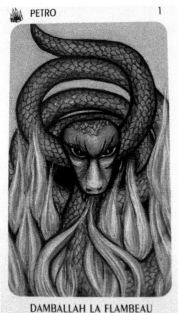

DAMBALLAH LA FLAMBEAU

The *World Egg* and *Damballah La Flambeau* tarot cards feature a snake, which is a strong symbol found in Voodoo art aesthetic. *Photo by Rory O'Neill Schmitt.*

Within New Orleans Voodoo and Vodou art, one will probably encounter images of snakes. Sallie Ann's artwork has included images of snakes. In *New Orleans Voodoo Tarot*, she created exciting, colorful and evocative tarot cards. One particular artwork that I was drawn to was *Damballah Wedo*.

Initially, this card is quite frightening. A long, thick serpent tightly wraps its maroon body around the limbs and trunk of a solid tree. Its anthropomorphic head hovers, with two slanting eyes staring directly at the viewer, the whites of which penetrate. The solid tree trunk, perhaps of a Louisiana oak, stands erect and shows a thickness almost mirroring the snake. Green leaves touch the snake's tail and gently hang overhead. Below, green and olive-colored blades of grass point upward, while longer blades of grass stretch toward the serpent. On the backdrop, smallish oval eggs of brown, white and yellow paint fall from a tan sky, like accentuated raindrops.

The artist composed thick lines, dramatically emphasized as if they were almost carved in wood. In the rope-like tree trunk and accentuated snake body and scales, the darkened lines act like borders. However, the painter also creates an intense sense of flow and unity to counteract the boundaries: multiple wavelike sections that stretch upward characterize the tree. In addition, the snake's coiled body wraps again and again around winding parts of the tree. The tree leaves and snakehead are rounded, as to decrease

any aggressiveness of the dark boundaries, without diminishing the artwork's intensity. Countering forces balance each other.

When comparing this artwork to *Petro Damballah La Flambeau* and *World Egg* tarot cards, one can identify the artist's technique of creating a winding, coiled body and outlines of thick dark lines. Intense energy emanates from the tornado-like movement. The foreground of the *Damballah La Flambeau* painting includes flowing flames, mimicking the outstretched grass of the *Damballah Wedo* painting. Meanwhile, the background of the *World Egg* painting is full of floating orbs, echoing the eggs of *Damballah Wedo*.

Analysis of Sallie Ann's artworks of natural and animal life forms leads to the discovery messages of fear and strength, anticipation and peace. Life gracefully intertwines in the natural environment. Through Glassman's artwork, we see that connection with nature brings solace in anxious times, when the greatest fear may be uncertainty.

CONCLUSION

This chapter offered an opportunity to meet religious leaders of New Orleans, as well as an examination of their contemporary art methods and symbols. The next chapter further explores the diverse art forms of New Orleans Voodoo.

NEW ORLEANS VOODOO: ART AND AESTHETICS

by Rory Schmitt

The New Orleans Voodoo Art Aesthetic

Have you ever fallen in love with art? Art and I have had multiple relationships: I've lost myself in art, broken up with art, been blinded by art, been rejected by art, been impregnated by art. Art starts with passion. A seed grows into a life with outstretched limbs, a being that thinks for its own and comes to challenge you on a daily basis. As an artist nurtures and protects her art like an infant, she recognizes how each artwork has its own identity, its connection to place and purpose and its own set of meanings, which change over time.

Spiritual art mirrors the soul and reflects a culture's and community's deeply held beliefs. In New Orleans, Voodoo art forms will excite and surprise you, evoking awe and wonder. In Voodoo aesthetics, references to death and spirits often reign. Initially, you might feel afraid or even shocked when you see skeletons, bones, skulls, cemeteries, headstones and coffins. Later, after learning more about Voodoo, you start to see them as humorous and playful. Simultaneously, you are beckoned to rethink your notions of death and the afterlife.

Artistic representations of the Lwas come to life as vèvès (akin to a deity's calling card) or reappropriated pictures of saints. Catholic Haitian influences of Vodou have led to the incorporation of chromolithographs of saints, which are color reproductions of paintings. These saints are found in Vodou, not by mistake but by miracle, according to Haitian art expert Donald Cosentino.

Left: This painting by Priestess Sula Spirit may make a connection to her work as a birth doula. *Courtesy of Sula Spirit.*

Below: This painting by Priestess Sallie Ann Glassman recalls Haitian mythology. Humans travel through the air in light orbs (seen in the upper right corner) and transform into animal forms. Looking at the painting from the artist's perspective, one can imagine being an onlooker peeking from behind trees to watch their free play. Vodou rejects judgment and invites freedom. Individuals embrace their animal selves with a deep respect for nature. *Courtesy of Sula Spirit.*

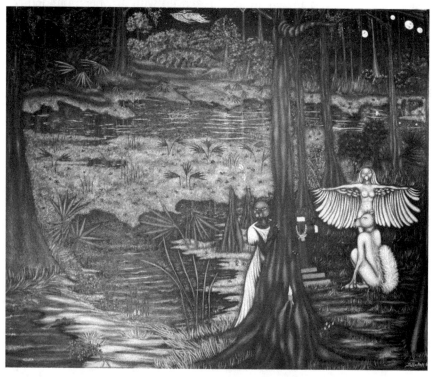

Voodoo art forms live within a spectrum of crafts, spiritual artifacts and fine art objects, crying out with their fierce colors. Vivid artworks draw upon an array of textures, natural and synthetic materials, as well as both refined and accessible materials. Acrylic paintings, iron wall hangings, dolls, sequin tapestries, beaded Lwa libation bottles, hand-painted gourds of Lwas and Orishas and wooden signs belong to the family of Voodoo art, reflecting the diversity and expansiveness of the Voodoo aesthetic.

Vodou and Vodun-inspired painters draw upon a variety of styles. You may reflect on the Divine Feminine or West African Orishas when viewing one of Janet Evans's paintings. Or you might identify Haitian influences in Sallie Ann Glassman's art. In one painting, she created a scene from a Vodou myth of humans transforming into animal forms to engage in revelry in a Louisiana swamp.

VOODOO DOLLS

Voodoo dolls are probably the most common of all Voodoo-inspired objects. Unfortunately, these dolls are deeply misunderstood. Handmade Voodoo dolls venerate specific Lwas, adorned in textiles that match their preferred colors. Vodou priestess Brandi Kelley told me, "Dolls are used, but these are for positive purposes, kind of like a spiritual acupuncture."

The history of the Voodoo doll stems from the period of Louisiana slavery. When enslaved peoples were forced to practice their spirituality in private, the doll became a special spiritual tool. Brandi told me, "Voodoo spirits began to be represented by Catholic imagery, and what you were able to do was practice the magic because you can take the doll, you can make a little mojo bag, you can do that in private."

Different spiritual tools, such as Juju dolls, can be found at Voodoo Authentica. *Photo by Rory O'Neill Schmitt.*

Drapos

Song is literally sewn into the fabric of Voodoo. When sewing a square or rectangular-shaped sequined ceremonial tapestry (called a *drapo* in Haitian Vodou), a practitioner sings specific songs, imbuing soul into the tapestry. When you look at a bedazzling tapestry in the colors of deep reds, bright magentas, gold, royal blues and turquoise, you must imagine the countless hours that the craftsman spent in painstakingly sewing on each sequin. Though sequins may be typecast as dainty, feminine or frivolous, drapos' representations of Lwas are bold.

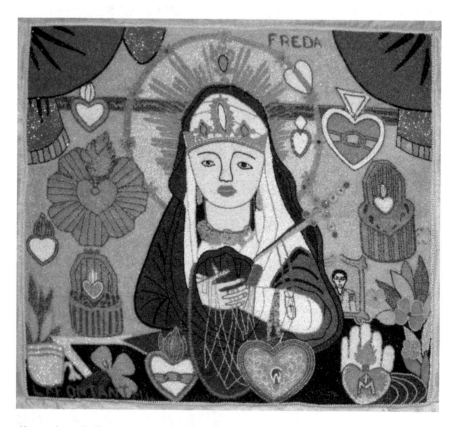

Above and opposite: Drapos are hand-crafted sequin tapestries with connections to Haitian Vodou practices. *Photos by Rory O'Neill Schmitt.*

Contemporary Art Related to New Orleans Voodoo

Three distinct art pieces, which strikingly contrast in their subject matter, style and usage of materials, offer different experiences. One particular spray paint mural honoring the Voodoo Queen is quite moving.

Marie Laveau Mural: Exploring How a Local Lwa Protects Her City

The art world of the twenty-first century embraces once-radical art materials. Some artists make their marks on walls—either inside homes or outside buildings.

On Rampart Street, between Piety and Desire Streets, Marie Laveau stands in a public mural at the entrance of Rosalie Alley. Two stories tall, she initially evokes fear. She is eternal on the side of that house; she watches and waits. Stoic, she reminds me of a Roman god protecting us at the end of the road before we march our way on foot to the temple. We greet her on entry, and we bid her farewell as we leave the sacrosanct space by the Archade Meadows temple in the Bywater.

Larger than life and bare-chested, Marie Laveau looks down at us with her skeleton-like face and deep-sunken, haunting eyes. Her head rests on her

A spray paint mural honoring Marie Laveau was created by Langston Allston. *Photo by Rory O'Neill Schmitt.*

hand in a relaxed gesture. Beneath, near her heart, lies a snake's head. With a wide-open mouth, fangs and hissing tongue, the serpent observes us, too. At nighttime, a spotlight projects a spectrum of colors, morphing the piece into a four-dimensional artwork and further resurrecting Marie.

Local Mariza restaurant owners Ian Schnoebelen and Laurie Casebonne commissioned the artist to create the mural on the side of their home. Ian met the mural artist, Langston Allston, when a friend commissioned him to paint a mural at his house, which was a remodeled bakery on Touro Street. Allston had just moved down from Illinois after obtaining his BFA from the University of Illinois in 2014. Ian said that the artist was "looking for other surfaces to paint on." Allston's exploration of space shows the expansive nature of contemporary American art: graffiti on walls of homes is the new oil on canvas. Art is indeed limitless!

The artist's process involved Allston exploring the alley and physically and mentally feeling the space that resonated with the Vodou temple. Then, Allston made the decision to paint Marie Laveau. Egon Schiele's painting *Standing Girl in Plaid Garment* inspired him. Ian mentioned that Schiele was his wife's favorite artist, bringing one to wonder: *Was this merely a coincidence, or were the spirits intervening?*

Inspiration of this Austrian painter, known for erotic and beautiful portraits of women, catapults Marie into 2018 as a modern-day heroine. In the mural, Marie is stripped and simultaneously unashamed. In addition, Allston's specialty of spray paint portraiture reflects feelings associated with graffiti art: rebellion, revolutionary spirit and power. Once seen as a subversive art form, graffiti art allowed individuals to defiantly express themselves, to claim space by making their marks both physically and symbolically. Evoking personal and communal power, graffiti is quite compatible with Voodoo. This contemporary mural shows us that Marie Laveau has not left New Orleans. Her watchful warrior eye fiercely protects us.

Congo Square and the Bamboula

In 2010, Adewalé Adenle created a sculpture commemorating Congo Square after winning a commission competition by the City of New Orleans. A Nigerian artist, Adenle told me that by sharing an African perspective of an African American experience, he could more closely relate the story to truth. When Caucasians tell Africans' and African Americans' stories, the narratives "tend to favor the masters." His work aims to clarify misunderstandings.

On a cold December day, I run through the rain to catch a glimpse of this Congo Square statue. As I approach, a walking group encircles the monument, and a tour guide briefly and unemotionally describes nineteenth-century New Orleans. Tourists, holding paper coffee cups, pose for pictures in front. I pause and wonder if they are able to recognize the pain associated with this period of history.

As I step closer to the sculpture, I see an African American couple dancing. The woman and man look at each other, smile and hold hands. Jettisoning out of the stone, the woman waves her shawl by her feet. Standing adjacent are figures with nearly identical heights; they appear almost flattened into the rock, as if cemented in time. At the right frame of the piece stands a child, whose mother lovingly wraps her arm around him. Even children were victims of slavery.

Two drummers and a banjo player flank the central couple, building the beat that contributes to the lively atmosphere of the bamboula. I recall that a local priestess told me where the word *jazz* comes from. In Congo Square, people asked, "What y'all doing?" The musicians responded, "We *jezz* playing."

I pay attention to the strategically placed instruments, including drums and a banjo, which Adenle had discussed during our conversation the week prior. When researching Congo Square, he identified violins in Benjamin Latrobe's eighteenth-century historical drawings. However, he learned that violins had been newly arrived in the United States. He determined the actual instrument was probably a similar-looking one, such as a goje or banjo. He also pointed out that the slave owners probably wouldn't give their violins to slaves to play on Sundays. Through his artwork, Adenle aims to correct history by providing more accurate representations.

Lastly, as I look to the bottom of the sculpture, I notice a long, thick metal chain. I remember that in our conversation, Adenle told me that he chose to include this item as an artistic device. He wanted to remind viewers: "free" on Sunday did not really mean free. These individuals were still slaves.

Visiting the Congo Square sculpture in person allowed me to meet history and to honor its survivors and their cultural heritage. Upon returning home to Phoenix and investigating my photographs, I noticed each person's face is so very realistic.

I later asked Adenle if he had chosen specific individuals to model these figures. He told me he completed many sketches from his research. However, he shared with me a serendipitous experience: in Congo Square about six years after he completed the artwork, Adenle was introduced to a

In 2010, Adewalé Adenle created this seven-by-thirteen-foot bronze sculpture, called *Congo Square and the Bamboula*. *Photo by Rory O'Neill Schmitt.*

Adewalé Adenle included this detail of chains as a poignant reminder that the institution of slavery persisted on Sundays. *Photo by Rory O'Neill Schmitt.*

Native American woman named Merline Kimble who shared an uncanny resemblance to a Native American woman in the sculpture. I questioned, *Was this serendipity or the ancestors at work?*

Through speaking with Adenle, I also came to better understand Yoruba culture and how it relates to Voodoo in New Orleans. Adenle speaks the Yoruba language and translated a book of sacred Orishas chants. He explained that these songs are not just songs you sing; the chants are integrated into rituals and penetrate your soul. Music arouses your spiritual being. I thought about the levity on the faces of the individuals in the sculpture. Perhaps they were in a state of ecstasy as the music played, and they could really let go and feel connection.

When Adenle lived in New Orleans, he was invited to Voodoo rituals and found New Orleans Voodoo to be very ceremonial and spiritually evocative. His perspective is that Voodoo is culturally enhancing to New Orleans. Indeed, Voodoo has been a part of New Orleans since its founding.

New Orleans Voodoo shares similarities with Vodun religious practices. In Nigeria, local residents call the spiritual, religious and medicinal practice *Juju*, not Voodoo. Adenle said that the American word *Voodoo* is projected as a mockery of the practice. Individuals only call it Voodoo to Americans because that's what they call it; that's what they understand.

Adenle shared that a challenge in Yoruba lands today is that shame surrounds this religion. An Ogun-worshiping priest may hide his practice with a shrine in his bedroom because Christians in the community may say he will burn in hell. Nigerians seem to be progressively following a Eurocentric ideology. However, many still believe in the religion and practice underground, trying not to expose it.

The underground nature of Juju in Nigeria reminded me of Louisiana's history wherein Voodoo practitioners celebrated their spirituality privately. Only more recently are individuals opening up about being identified as Voodoo practitioners. A brave and compassionate priestess who holds a St. John's Eve ceremony annually in Congo Square shared with me, "We are coming out from the shadows."

My Altars

Through the practice of creating a Voodoo altar, Voodoo practitioners develop sacred meditation spaces. Through nurturing that altar, they participate in automatic daily rituals that support and inspire their spiritual lives. Many are inspired by Voodoo's practices in their evolving spirituality.

The artist creating the *Congo Square and the Bamboula* statue. *Courtesy of Adewalé Adenle.*

On the windowsill over my desk, my eyes linger to the objects on my saints and Lwas altar, including a Russian egg nesting doll (on which an artist painted the Virgin Mary holding infant Jesus); a hanging wooden Indonesian mask with a bird crown; a golden smiling skull; a glittery pink wine bottle with a glass candy ornament; a photograph of a magenta sunset; a royal blue New Orleans Sewage and Water Board window placard; a miniature, glow-in-the-dark Mary plastic figurine; small white votive candles; and a folk art sign trimmed in Abita beer bottle caps that says "Sin, Repent, Repeat."

Recently, I found a broken wing of an antique wooden angel. To me, it resembled the palm of an outreached hand. So I found the wing a new home on my altar, a space of devotion. Then, I placed on it the prayer card of St. Veronica, the patron saint of photographers (perhaps because she wiped the face of Christ and was forever left with a miraculous shroud). The wing of the angel holds a saint.

Interaction occurs between these artifacts: angel/saint/Jesus. The wing is holding Veronica, offering her a supportive, safe place to lean on; Veronica is venerated for showing compassion to Jesus in a time of deep suffering. A simple kind act of wiping someone's face can mean so much.

The author's desk with a Voodoo altar offers both grounding and inspiration. *Photo by Rory O'Neill Schmitt.*

When my eyes linger on my altar, I'm reminded of strong, religious women who gave me the objects and continually support me (my godmother, my mother and sisters). Altar-making invites opportunities to create new spiritual connections, leading us to discover meanings beyond words.

Altars also help Voodoo practitioners communicate with their ancestors, who look over, protect and advise them. New Orleanians deeply value family, and they celebrate their lineage. On a shelf in my bedroom closet, my ancestor altar holds a framed black-and-white photograph of my grandmother Dorothy Donovan O'Neill. When my father was only a few years old, his mother tragically died in childbirth. Her life inspired me to take her name at my confirmation and also elect to have two C-sections.

On this altar, I also remember my maternal grandmother, Rosary Nix Hartel, when I regard her silver baby ring. She is my namesake, as well as my mother's. Only at her funeral did I learn the reason her parents chose her name. Her father, James Thomas Nix, was a devout Catholic and prayed the rosary before each surgery he performed. In 1940, she assisted him with publishing his book, *A Surgeon Reflects*. She was brilliant (obtaining master's degrees in French and English literature from Barnard College in 1938) and incredibly humble, and I still admire my grandmother's kindness and devotion to the family. I would walk home to her home on Fountainbleau Drive every day after high school at St. Mary's Dominican. I'd make her an old fashioned (cocktail) and sit by her feet while I gave her a manicure as she watched Mass on TV.

On the wall of my altar is a framed picture of Our Lord's Prayer. I retrieved this family heirloom from my sister Dale Ellen. It holds a memory of our childhood home on Carrollton Avenue, a pink raised cottage that was owned by my mother's family for three generations. It was displayed on the wall over the antique kneeler in our parents' bedroom, where sometimes we would pray.

Interactions with New Orleans Voodoo inspires many other visitors of the city. For instance, Dr. Julye Bidmore, a religion studies scholar, taught a summer graduate course on Voodoo in New Orleans. Upon returning back to Chapman University in California, together with her students, she created an altar. Indeed, a fascinating part of Voodoo is its invitation to create beauty. She stated, "The way the altars are set up is itself artwork."

They honored Erzuli Freda Daomé, the Lwa of love and beauty, with their altar. This altar shows Voodoo syncretism. Catholic components can be seen in the rosary prayer beads, as well as Erzuli Freda depicted as Mother Mary in a wooden Russian nesting doll and a framed *Mater Dolarosa Ezili Frida*

The author's ancestor altar includes a framed prayer from her childhood home. *Photo by Rory O'Neill Schmitt.*

painting (by local Marie Laveau scholar Carolyn Long). Voodoo artifacts coexist; we notice an African-inspired Orishas doll cloaked in pink and a pink candle with a vèvè.

The altar also includes offerings to Erzuli Freda that matched her personality. Since she adores love and luxury, students provided pearls, roses and even a sparkly crown decorated with a heart. The table is encircled with a chain of hearts, reminding viewers of the strength that union provides. Even miniature statues of a bride and groom (in a top hat) show that love wins.

Lastly, creation of this altar involved object repurposing. Through placing ordinary utilitarian items on the altar, new meanings are created. A hurricane candle that features the Virgin Mary emphasized that she brings light, solace and protection. Meanwhile, Mardi Gras beads and a champagne glass filled with gems reflect celebration and jubilation.

Reading about, viewing and creating Voodoo altars invite a greater appreciation of this artful spiritual practice. Within the context of the altar, integration and interaction provide opportunities to constantly change one's environments, build new meanings and grow spiritually. Intentional acts that continually evolve, altars invite individuals to artfully arrange, combine and create objects until their altar feels pleasing to them. Often, altars metamorphize over time, as one adds new items and recycles others. As bricolage, altars are a form of ever-evolving collage, wherein one is melding things together, combining disparate parts of the self or world to create one cohesive whole. Within an altar, there are several layers: artifacts beneath, above, behind and next to each other. Altars may appear very busy, but the colors, textures and images are solid and very grounding, planting a sense of peace.

Altars are living sculptures that exist in living rooms, closets, bookshelves, windowsills and backyards. Neither their location nor functionality precludes them from being artwork. At the end of the twentieth century,

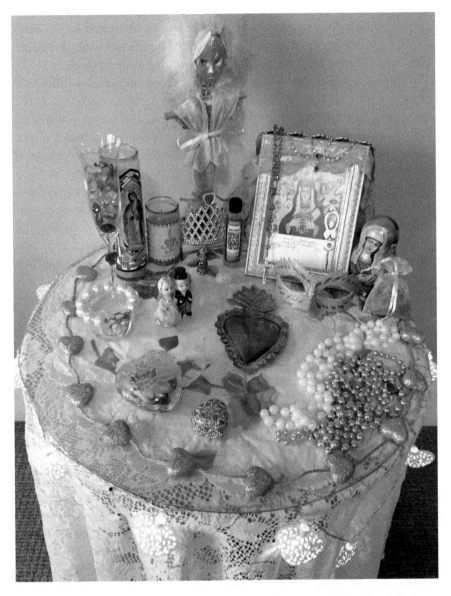

Religious scholar Dr. Julye Bidmore created this altar in homage to the Lwa Erzuli Freda. *Courtesy of Dr. Julye Bidmore.*

the contemporary art world recognized altars as art objects. For instance, in 1996, the Los Angeles Fowler Museum of Cultural History (University of California) hosted a Haitian Vodou art exhibit, featuring altars. Prior to that, in 1979, the New Orleans Museum of Art hosted a traveling Haitian art

exhibit that included paintings, drawings, sculptures, altars and a re-created temple. Researching the museum archives in its downstairs vault, I became elated when I recognized images of Erzuli, Damballah and Ghede.

Voodoo altars share ties to Catholic altars. However, a major difference between Catholic and Voodoo altars is related to accessibility. Some questions to consider are: How close can you get? What can you touch? While Catholics are prohibited from entering and touching church altars, Voodoo practitioners invite you to cross boundaries—both physically and metaphysically. When individuals create their own altars, they are then powerfully included in the story. In fact, witnesses become key players—not quiet, distant observers. Perhaps Voodoo altars invite the development of feelings of freedom and autonomy. You might also consider the ramifications to the answers to these questions: Can you add symbolic objects to the altar? Can you move objects around? Can you respectfully share offerings and petitions?

Through altars, individuals show their yearning for protection, a desire to find meaning, a need to understand the Divine and the means to request help for things that feel outside their control.

CONCLUSION

In New Orleans, Voodoo art mirrors the soul, reflects the Divine and transmits messages from another realm. Key to understanding Voodoo art forms in the New Orleans art world is recognizing that objects hold significance in whom they represent: Le Bon Dieu, Lwas, Orishas or ancestors. And artful objects hold value in the purposes they serve: to venerate, petition, appease, express gratitude or remember.

Accessible objects, like embroidered flags and dolls, are sacred art forms that regular people touch and use to bring about healing, as well as feelings of peace and joy. The objects come alive when helping someone. When fearful, you can reach into your pocket and hold a symbolic object, like a crucifix, a chicken foot fetish or gris-gris.

Voodoo art is seldom created for the sake of Western fine art idealism: to hang on pristine white walls, admired from afar and never touched. Rather, it serves unique purposes, acts as personal expressions and carries individual and collective meanings. Art is connection to self, others—both living and dead—and Spirit. Its making can be a grounding experience, as well as a transformational one.

This chapter explored the unbelievable breadth and depth of New Orleans Voodoo art and aesthetics. Indeed, history and spiritual practice inform the art forms that develop. The next chapter discusses the performative functions of Voodoo in music, dance and drama.

DRAMA, DANCES, DEATH!

by Rosary O'Neill

PUBLIC PERFORMANCE IN NEW ORLEANS

New Orleanians love to dramatize: to sing, dance and shout. Silence rarely visits the Big Easy. Walking down Chartres Street, one has to zigzag around musicians playing, women frolicking, men leaning against a wall tapping their feet as people pass.

By the Mississippi River and Café du Monde, youths do skateboard leaps to a cheering crowd. Near Jackson Square, a band (in Santa costumes) is mixing up because a parade is coming down Decatur Street. Then, in the 500 block of Royal Street, an actor in black cape and full dress is setting up speakers for a gothic performance. New Orleans, the revelry capital of the world, hosts over 153 festivals a year. Daily, artists perform in French Quarter streets.

This chapter explores public and private rituals of Voodoo and their connections to New Orleans.

A CELEBRATORY LIFE

New Orleanians have been "partying" for a long time. As far back as the early nineteenth century, shocked out-of-towners gawked at this Deep South den of iniquity, ruing the countless rum houses, billiard halls, saloons and back-alley dispensaries that often remained open on Sundays. By 1853,

French geographer Elisée Réclus regretfully estimated that New Orleans was home to some 2,500 drinking establishments. Drinking was a way to deal with misery. But had Voodoo practitioners found another?

Sacred dancing and singing helped many enslaved practitioners embrace an untenable life. Women needing prayer crowded together, as they were in a disease-ridden port city rife with hurricanes and crime. Some cried for whole nights, went into their rooms and let themselves sob as they faced death and desertion. Often, a Voodoo sister might come in and just hold a person. Then she might help her find clean sheets, warm a bath, freshen a room or just sit with others and empathize.

In the French Quarter today, if it's your birthday, people pin money on you. That tradition comes from the nineteenth century, when so many people died young that if you lived past the age of five, you got rewarded with money.

During epidemics, death surrounded New Orleans like a thick fog. Individuals had to bury their dead and find healing. Funeral processions were charged with movements from African dances, such as exaggerated, loosely coordinated strutting, marching, the swaying gate (a snake-like movement).

Later, similar steps appeared in second-line funeral marches. People vented the soul's sorrow with the customary weeping and wailing. Then they accompanied the dead to their resting place with singing, the beating of drums and tambourines and dancing the soul to its new home. Some have pointed out that the funeral dance was copulatory because there can be no rebirth without sex.

Today, Voodoo practitioners continue to celebrate death. As the manager of the Voodoo Museum for over twenty years says, "We have a wake at a dinner, T-shirts with the beloved's face on them, bookmarks, flyers, a second line, a breakfast, a dinner the night before. You'll almost have four days of funeral." Dancing, music and rites help the bereaved return to life less broken.

Additional Voodoo rites send praise to the spirits through music and dance, as well. Historically, Congo Square ceremonies included a drum beat, a roll, gourds and banjo-like music. Dancers started moving back and forth to the beat and calling upon God or moving into a circle and swaying. Songs, passed down orally for centuries, accompanied by patting, clapping and foot stomping, were used to open the gate between the deities and the human world. Along Bayou St. John and the shores of Lake Pontchartrain, historic accounts describe Voodoo practitioners ecstatically dancing during ceremonies and celebrations.

This painting at the New Orleans Historic Voodoo Museum features a snake dance. *Photo by Rory O'Neill Schmitt.*

Public Ceremonies

There is a formula for ceremonies in anthropology, a sort of pattern. Certain things are expected, certain things are unexpected and transformation is the ultimate goal. Although there are hundreds of ways to have a service, many have seen some done in church or synagogue, and they follow this process:

1) You prepare the sacred space, its altars and borders so people know where the ceremony is, what to do and that they are safe.
2) You gather. Participants arrive wearing something purposeful for the occasion.
3) You invoke the spirit.

Voodoo rites are done to call the spirit into the body for the purpose of doing good, i.e., performing a blessing, a healing or honoring an ancestor(s) or practitioners present. Songs open the gate between the deities and the human world.

The Lwas arrive by mounting a ritualist, who is said to be "ridden." This can be either a very quiet or violent occurrence, as the ritualist can flail or simply slide to the ground. Possession trances come at the end when the spirits have been called in, are gathered and are doing their work. People are free to participate in the possession trances. Attendees take very good care of anyone who is possessed. Once having this possession experience, practitioners say they are never the same. It's an extraordinary honor and a life-changing event.

Private Rituals

In the tradition of sacred privacy, Voodoo is and has always been a place to express innermost thoughts that don't otherwise get talked about. Many Voodoo devotees today practice in their homes, kneeling, bowing their heads and witnessing that we all are the servants of God.

Voodoo is a highly personal religion. One practitioner explained her prayer practice:

> *I usually pray in the morning before I get out of the bed. I read or journal or pray when I am cooking. That would be the time I am tending to the altar, so it kind of goes together. Maybe I'll be thinking about a person who is*

sick, so I'll write it on a paper and put it there. Sometimes if I am really in a crisis, then I will set up the kitchen table, my grandmother's table, with a bowl of water, a candle and tarot cards. Sometimes I pull out the big guns, but on a daily basis, prayer happens as part of my day.

Another devotee describes her prayer life as follows: "I pray. Not necessarily all night. Most of the day. It's not like someone saying, 'Get up, you have to go to church.' That's why I love prayer; it's never a chore."

ALTARS

Much praying takes place before private altars. One ritual at the altar includes placing the bowl of water in the center of the table and the white candle behind it and a bowl of food before it and speaking to spirits, first by honoring them aloud and asking for guidance for problems and then by offering ancestors food and drink and thanking them for listening.

Voodoo practitioners create varied altars: altars that have money, spirits, gratitude altars, Catholic saints, singular saints, special Voodoo Lwas. An altar might display stones, dried animal heads or parts, elaborate statues of diverse Voodoo gods, images, cards, statues or crosses. At Voodoo Authentica, huge wooden masks from Africa with giant jaws dangle over the altars. At the Voodoo Museum in New Orleans, altars tease you with skulls chewing on cigarettes, pennies strewn over ashes and old photos of pythons wrapped around dancers. A practitioner describes the altars at the Voodoo Museum:

This stuff you see here looks like junk; it's called offerings. You place it on the altar wherever the spirit guides you. When you worship the spirit of someone who went before you are talking about them, you're keeping them alive. Flesh goes to the ground; spirit stays with us.

This altar is not my altar, my place of business, my house, my museum, my shrine, my temple; it's not my home, it's a place of employment because I'm here now standing in the act I can call it as I like. It's not clean, it's not organized, it's not neat....Everybody who places offerings here does it from the love of their heart and thought of their mind. [Points out pictures]

A Voodoo practitioner's ancestral altar is a first step to connecting with spirits of the dead. An antenna for other spirits, the altar demonstrates how the practitioner venerates and wishes to work with spirits.

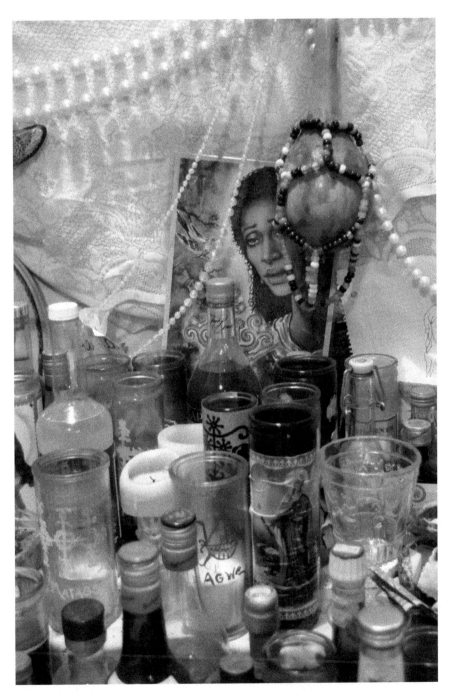

Offerings on an altar at a local Vodou temple. *Photo by Rory O'Neill Schmitt.*

Practitioners do not worship the ancestors; they honor and respect them and ask for guidance. Any and all connection to the spirit world depends on the strength of this ancestral connection/altar, which may include a table, photos and mementos, a candle, a portion of each meal of the day or a dish with nine different types of earth, including graveyard dirt.

One Voodoo priest shares, "Ancestors are in your blood. They are a part of you. However, that relationship needs to be cultivated, but it takes work. Ancestors, the dead, surround us every day. You don't need to have a dream to see them or speak with them."

An altar can honor biological ancestors, the universal archetypal ancestors or both. I asked Priestess Sallie Ann Glassman if she used biblical ancestors or more recent ones, and she said:

> In my mind, Voodoo's roots are in the oldest religion, the mother religion. The other religions evolved out of that and follow a great deal from Voodoo. We can argue forever when the cross originated, with Jesus or as an African symbol that refers to the movement of God through the universe as creative energy. So the question becomes: Do we appropriate the new?
>
> We see only a few of the saints that are absolutely served as that person and not as a mask for somebody else. John the Baptist shows up in Voodoo: St. James Major, the spirit of St. Jacques, so there's bleed through. New people becoming spirits, like Marie Laveau in New Orleans; for us, she's definitely becoming an archetypal spirit.

Practitioners pay respect through ritual, prayer, evocation and donation (putting gifts to specific beings on the altar). Gratitude altars feature thank-you gifts for blessings. The manager of the Voodoo Museum points out her gratitude altar and says, "Prayer and the altars help me the most to receive a certain type of energy. As long as I'm giving back to the spirits, I know they'll take care of me."

I must admit that since writing this book, I've created two altar areas in my house: in my bedroom and on a bookshelf in the living room. When my eyes roam to those altars, the holy rosary and picture of Our Lady on each do remind me of a spiritual power. As a writer, I'm moved by holy ones who have gone before, and I like such reminders. Both my mother and my grandmother (devout Catholics) had altars in their bedrooms. I'm reminded of the ritual of daily prayer.

THE MAINTENANCE OF ALTARS

In most Voodoo practitioners' houses, the altars are in the kitchen, the office or the living room. One practitioner says, "When you open the front door to my house, the altar is right in your face. This is like you don't have to worry about the reception you get from other people because we have your back. They have never let me down in passing on a message. The accuracy has been there no matter how many times I do it. And it's in the hundreds."

To my statement that maintaining the altar takes a lot of time, one Voodoo practitioner responded, "It doesn't when you get used to it. It's like feeding the dog. You don't think about it too much anymore."

A priestess says that private altars threaten to take over her house. She said every time her husband looks down, some other surface has been taken over by a different spirit. That's one of the things about Voodoo; you start to see everything as ritual. And you see every surface as an altar, and standing at a crossroads between the spiritual and the visible, the world gets quite a bit richer and more sacred.

Voodoo practitioners take care of the altar, change the water, candy, rum. They believe you can't let it get dirty or dusty. Keeping the altars clean reminds them to be humble before Spirit, to never believe they know more than they do, to remember that spirit communication depends on their willingness to accept what they don't always understand.

The upkeep of the altars also reminds practitioners to keep an open heart when it comes to Voodoo. For them, it's all about their altars, wanting to freshen them up and make them pretty and feel that energy. Whichever spirits they're working with, they have to know what they want: the right whiskey, a pack of Lucky Strikes, a baby cup of coffee, a little plate of fried chicken. The altar is a way for ancestors to come through that practitioners are supposed to do something for. Sometimes, they will see ancestors. They keep their altars burning and believe in all these spirits having their backs.

ADDITIONAL HOME RITUALS

Home rituals show how individuals privately live out their spirituality. For example, one grandmother sanctified water by setting a jar of water with stickers of Jesus on it under the full moon and sprinkling water on her sheets at night. Another practitioner had a Catholic altar in her closet with saints and various effigies corresponding to spirits in Voodoo. She lights a candle

and says, "This is Lazareth. Lazareth is the same as Legba. They both are old gatekeepers with canes." Still another practitioner had a shelf in the armoire and a kneeler with a rosary hanging on it at the end of the bed. She'd move the kneeler to the armoire, open it and say Catholic and Voodoo prayers.

Often, these female Voodoo practitioners I spoke to weren't explicitly teaching the younger generation their religion. For example, one Lafayette mother allowed her daughter to watch her while she bought a cow tongue from a butcher, cut its middle in half, put the name of somebody who was talking ugly about her in the tongue, tied it up and buried it in the yard so that woman would stop slandering. Other women would clean the house, smoothing out the bad energy that made them furious. Others might salt every room in the house and get rid of salt at the middle of a road crossing, saying, "In this world we deal with depression and isolation, and we don't need the weight of the past or dark energies attached to our house."

These practitioners reported that they didn't say too much too early because they didn't want their children to go about spouting that they were doing Voodoo. The young ones grew up observing these rituals and later came to understand and continue doing what their family did. To them, Voodoo feels more comfortable and natural, whereas church felt forced, not real.

Voodoo and Love

Voodoo comes from love. Practitioners' deep love for Spirit fills them, and they express it through rituals, creative acts, interactions with people and all the praying they have done and continue to do. Voodoo practitioners strongly desire to support their family, friends and followers in the most loving and positive ways. For them, holiness is being loving, and positivity is the key to God. Many practitioners believe that God is a part of everything in nature and energetically we are all connected to one another.

Closing

In a society that often celebrates youth, Voodoo celebrates age. In a society that focuses on children, Voodoo respects what the wisest elder has to say. Through examining spirituality practices, readers can come to know who the practitioners are today. The next chapter finalizes the story of New Orleans Voodoo and art by presenting this sacred religion's connections to its city.

NEW ORLEANS VOODOO AND ART CONNECTIONS

by Rosary O'Neill

ART AND NEW ORLEANS VOODOO

Art shares a deep connection to New Orleans Voodoo spirituality. Focusing intention and opening up to receiving guidance unseal the window to Spirit and creativity.

For Sallie Ann Glassman, practicing Vodou and being a mambo have helped explain to her what she's doing in her art in the same way that going to study art deepened her appreciation of the world she was seeing. It wasn't just a blob of green paint; it had depth, structure, light, shadow and gradations of color. Sallie Ann says:

> I've always painted the world the way I see it, but the invisible ended up showing through: the life force in the painting. And the work with Voodoo has shown me that is not just a quirk, that it is what I'm really seeing, that is how the world is really organized....My sense of death is starting to orientate to quantum physics' view of alternate universes that time is not real, everything is happening simultaneously and alternatively. And again, the invisible and visible experience now are interchanging and interacting, so it's almost a "bleeding" that happens in our current life.

Writers, dancers, musicians and community members also feel their lives enriched through Vodou. This spiritual practice cements the ability to see life on both visible and invisible planes. Martha Ward said, "Voodoo has brought me closer to the world of spirits in huge amounts. In my worldview, God sends these spirits, and in my experience, they are all kind and compassionate. And we can access that compassion."

COMPASSION AND POWER

Compassion is a consistent experience of Voodoo. Where does that compassion come from? Some believe it's divine, it's sacred, it's available to all, but humans aren't powerful enough to generate compassion by themselves. Some locals go to ceremonies because they see these community rituals as embodied compassion. In an ever-changing and anxious world, Voodoo provides a community of grace.

Martha Ward explains, "Voodoo is very muscular....It's not wimpy; it's not about releasing pent-up feelings. This is real action in a real world that is hostile, frequently, rugged and terrifying....It's really heroic in that style of honoring the spirits."

She explains, "Voodoo works because the spirits are in charge, not a person, not the client, not the therapist—it's the spirits. They want to help you. They already are. They come from total goodness, from a connection to some other realm that we're not in. Who knows what that looks like, but it's wonderful to have that connection."

CLOSING REMARKS

An exploration of the lives of Voodoo community members, artists and their rituals gives rise to fierce insight and expressiveness. New Orleans Voodoo helps people heal, strengthen and grow creatively and powerfully.

Well, dear reader, we bid you sweet blessings from New Orleans and all who hold dear the religion of Voodoo. And whisper that Voodoo has indeed brought us closer to God.

ROSARY O'NEILL'S READING
WITH A VODOU PRIESTESS

February 24, 2018, New Orleans

BACKGROUND ABOUT PSYCHIC CONSULTATIONS
AND MEDIUMSHIP

The word *psychic* is derived from the Greek and means "soul." Psychics, Voodoo and otherwise, have long been a part of New Orleans history. Private consultations may help practitioners find strength. Many locals have had their palms, stones, tea leaves and tarot cards read many times. Usually the reading begins with a question: "Are there any issues you are concerned about?" During readings, the reader's connection with the visible and invisible worlds allows her to go between images and intuitive feelings and appropriately advise the clients. Is mediumship different in Voodoo?

Mediumship in Voodoo is prayer-based. It comes because the practitioner spends time at the altar and does the sacred rituals that her grandmother or mentor taught her. Voodoo mediums are in touch with both sides: the real world and the divine. Any time a medium gets double information, it is super supportive because she is being confirmed from the other side. They call it a "check-in," as if spirits are letting them know something.

Each Voodoo practitioner who finds herself a medium has a proclivity to a method of consultation. Someone is superb with stones, palm or dreams. Visitation dreams come when a practitioner needs to reach out and tell someone something. They differ because of their clarity, brevity and insight. Something is said in the dream that is pretty straightforward and is more like reality than a dream. Voodoo practitioners learn over time to be brave

enough to tell someone the dream with no interpretation whatsoever. They speak straight, although they fear the listener may be scared when they hear the dream that they are going to die.

Mediums have all this information, and sometimes it feels overwhelming. They, too, are afraid of the aftermath of death and that their families won't be okay. Some are worried that if they are sensitive to all these energies, even when they go, they're going to be one of those people who are still around.

Crossing over into the world of the invisible seems fairly normal to many Voodoo practitioners. Many seem to have had surreal experiences, like experiencing the rattling of closet doors, spirits going like wind through the hall or the appearance of the recently dead.

Healthy Voodoo practitioners also seek advice. One described a helpful session she had with a priestess:

> *When I was home [in America] from Haiti, my boyfriend left after three years. I went to see a priestess, and I had never met her, and she said, "Oh, you walked in because he left you. There's another woman. She's younger." The priestess told me everything I didn't know. And it was all true. I had a direct connection to another realm. She told me that it was coming through; the spirits had told her.*

Voodoo consultations may provide razor-sharp truthful descriptions of an unknown person's behavior.

ROSARY'S CONSULTATION WITH A VODOU PRIESTESS

We go into a dark, curtained back room off her Voodoo shop and sit at a small cloth-covered card table by a wall. Behind her is a curtained bookcase, and before her is a tennis ball–sized crystal ball. Prior to the reading, she gives me a ballpoint pen and loose-leaf notebook and says when she's in a trance she won't remember anything, so write it down. She asks if she should speak freely or answer specific questions. Nervous, I've forgotten to put a question in my pocket as a colleague advised, although I've worn a vest with a pocket for that purpose.

The priestess allows me to tape her but says 50 percent of the time, recorded tapes come out blank. After recording her, it takes me twenty minutes to access the tape; the voice speeds by squeaky fast, then the tape appears blank, then there's a low, gravelly voice. Finally, by adjusting the

speed many times, I'm able to make the voice understandable. I've never had to do that before to replay an interview. After I type it up, the file window on my computer reopens about twenty times inside itself, threatening to malfunction. Every time I revise the document, these mystical windows within windows explode on the screen. I'm hoping they are telling me I can learn more by studying this priestess's words. I'm relieved I can transmit this interview to you. I am keeping a paper version of it in my desk nevertheless, in case of an unforeseen crash in transmission.

The interview begins with the priestess peering into the crystal ball. It takes about a minute or two for her to get into the spirit, but her face and voice don't change.

ME: What is the best way for me to walk stronger as a person?

PRIESTESS: So coming up immediately is the sense of you allowing people to help and to not always be the source of strength and leadership, that this is the time for attuning yourself to the natural response, and to go deeply into yourself to feel and not judge that response, but to be objectively observant about what your body is telling you and how your energy has responded, and above all to allow yourself to be able to let outside forces come in and take some burden off of you. It's all so very important to bear in mind—*time*.

[It's true; I'm very self-motivated, hurrying time. I need to be the driver. Divorced at thirty with two kids, I had to drive through a PhD, a college teaching job and artistic directorship of a professional theater, which I also founded. But then the priestess consoles me.]

PRIESTESS: Everything is at its right time, including death; it is just not something you need to worry about.

[I do worry about death. Since I had breast cancer twelve years ago and had to face down death, I have a great sense of the ticking clock and am so grateful for another day. Actually, the dread of death motivated me to get sixteen plays published in one swoop. Urgency led to positive action. I didn't want to die with all my plays in a trashcan.]

PRIESTESS: Death's not something you need to influence. This is a time for lifting off those kinds of worries. They don't serve. And for letting yourself be absolutely free in who you are, what you like, what you want to do with your time, and for you that freedom is powerful.

[This scares me. Am I going to die soon? Is that why the priestess started with this? And of course I want to be free in who I am if I can, but that abstraction "freedom" confuses me.]

ME: I have so many writing projects. I don't know which one to do first. I want to do the one that empowers and helps the most people.

[Again, my uncertainty in myself comes out. Do all women have this? I always feel that someone "knows the answer." Like many women, I worry that I'm using "confusion" to avoid action.]

PRIESTESS: So it feels like there is a distraction going on with all these different directions that are possible in your writing, and it's because the one that's most important to you, the one that matters the most, is the one that's going to draw you to your most raw, authentic self.

[Bingo. I do dread exposing my "evil self/the self I am ashamed of" outside the private confessional with its grill to hide behind. Many dismiss writing as therapy. I initially came to writing to share "my deepest self" as an artist. This week in the weekly workshop I take as a student (I've been studying in a class every week for twenty-five years), I discovered fiction is now valued less than poetry because poetry has the potential of an audience and income when used as lyrics for music, and fiction has little to none.]

[The priestess goes on, identifying the heart of the process, writing from the raw.]

PRIESTESS: As you get in touch with [your writing that's most important], it feels almost self-serving to go there. But the sense here is that in going to that core, in asking yourself, *what about this matters to me?* and continuing to ask that question, going deeper and deeper into the raw of it, what everyone is most afraid of showing or knowing about themselves, then that brings out such authentic experience that it does in fact resonate.

[She talks about the difficulty of being authentic because so much writing is stylized genre prose written to sell to a certain market. I, too, fear having no one read my work. I mean, some stories I've spent over five years on; can I justify that gift of time to them as opposed to other humans if the stories only contribute to my own enlightenment? I explain the difference in two writing projects I'm involved with to see if she finds the "loss of time" in one more valuable than in another. Astonishingly, she pinpoints the connectivity of the two projects.]

PRIESTESS: One project is largely rooted in your family. The other one is historically based on Degas and his dysfunctional family in New Orleans. They seem to be doing a kind of dance around each other, and even in exploring Degas's dysfunction, what you are really doing is exploring your own family. And it's just human stuff. So I don't think you need to choose between them, and it also seems to have a very reflective quality, like you are looking in a magic mirror and these two mirrors are set up—his family, your family, facing each other and reflecting eternally.

And so that has something to do with a reflective time. Let yourself observe what's happening and reflect the natural responses, so as you conjecture into Degas's family with whatever historical facts you know, you are able to reach into the historical story, what's motivating.

It's very interesting that this can become a technique for your writing in general that as you ask yourself what about Degas's story matters to me and avoid the whys (why does it matter to me). It's what about it matters to me. As you get deeper and deeper into that question, ask yourself how does that feel, and then you are writing from that response, so I think you can do both at once.

[So empowered am I by this duality that I tell a director I'm working with on a contemporary project, and he wants to read the Degas story to see how it aligns with the contemporary one. Who knew? From work worries, my thoughts spin to my adult children, family being a second passion.]

ME: What about my children; how can I do what's best for them?

[As an ambitious writer who loves work, I'm eager to further my children always. This comes from adoration and guilt. I'm crazy about them and don't want to screw them up in any way.]

PRIESTESS: First of all, this ability that you have to just objectively observe the facts, the realities, this is helpful to your children. This isn't conjecture, imagination. These are the realities, and you help them to get…You know you are also a very magical person. Sometimes people miss this. You are certainly very psychologically active and observant, and so sometimes people forget there's a real life that's going on and there are demands and they have to be met.

You can help your children to maintain that spiritual life, that sort of mystical way of experiencing life, and at the same time get down with what's

right in front of them in the physical. This is you observing objectively as though this were a meditation and without attaching unnecessary emotion or suffering to it. Just saying okay, these are the realities that you are dealing with, and maybe asking the person what's your plan, how are you going to deal with this moving forward.

ME: What do you think God wants me to do with the rest of my life?

[Again, this need to use time well driven by my fear of death. Is this a recurring theme in all over fifty?]

PRIESTESS: What comes up immediately is enjoy it. It's a gift, and you're enjoying yourself at this time, first of all it gives you a great deal more time than someone else might have at this point of your life. God wants to see you living fully and expressing that into the world. And living unapologetically in your power, in who you are. It has far more effect than you think it does in the world. Enjoy it, that's all.

[She's right. I'm a Puritan. Work, work, work, and when you're tired, work some more. My dad used to rate a man's success by how much leisure he had in his life. He and my mom played cards every night for fifty years. But for a working mother like myself with a writing ambition, patches of leisure were used for art. Now that my kids are grown, I can enjoy writing. But how do I maximize joy in my writing? The priestess explains that we get more time out of enjoying time. Now that's a motivator!]

PRIESTESS: So waking up each day feeling like there isn't enough time is really stealing life and energy from you. It's like people feeling they don't have enough money. They are always living in that frantic state. So if you can, relax a little and just enjoy what you are producing, revel in it and get a little bit more into being present to what you are doing right now and stop worrying about all the rest on your plate. It will actually extend the productivity of the time and make it seem longer to you. Just being present. This is what we're doing fully right now, taking out all the noise—"Oh my God, I got this to do, and that to do"—invades and takes away from "presence."

ME: Should I travel?

PRIESTESS: Travel feels actually positive. It knocks you out of your habits and has a refreshing effect. Again, I would say, do it with the sense of this is

fully what I'm doing right now, and put your attention on it and enjoy it. It's nice to have a bit of a sea change, to get away from what you know in the sense that as you are teaching you are dumping information and receiving new info.

[But then my heart sinks. The idea of travel threads through with the idea of illness. My traveling companion has cancer. I'm recovering from ankle replacement surgery.]

ME: How should I deal with infirmity: my friend who has serious cancer, I'm recovering from two broken ankles?

PRIESTESS: As far as your dear friend who has cancer is concerned, that's a struggle. He is very frightened. It's certainly not what he wants for himself. He's very confused about what he wants in this situation. He's being told a lot, especially by doctors, so if you can try to suggest to him that he sit down and really talk to the cells of his own body, to get the doctors of his head and the frightened voices and the people who care about him, and just sit down and introduce his consciousness to himself. "You know, hey, it's me. Thank you for getting my attention. I'm listening. What do you need from me? What are the changes you need me to make?" And then to listen deeply. His head is going to tell him all kinds of things, but he wants to go deeper than that to hear what the felt sense is.

Even if it's a difficult feeling that comes up, an anxiety, a terror, naming it, being able to recognize it, allows his body to shift a little bit. His cancer has a lot to do with fear, things he is afraid to look at, and so what may come up for him may be about how he responds to fear. That it's okay for him to be afraid, if that's what he is feeling, but to rearrange his relationship to that fear. And to empower himself to walk through that fear into his truth.

So that's a tall order. It's not that easily done, but his back is up against the wall, so it's an opportunity for him. I feel that he can find some peace there, and peace is the greatest restorative for him now. Calming down that fear, the voices, people telling him what he has to do, not feeling it from inside himself that that's what he chooses to do.

His daughter's drug addiction could have easily kick-started the cancer.

[Rearranging the relationship to fear stings me. When I am truly terrified, I pray and imagine the Virgin Mary's loving arms around me. I tell myself she would never allow me to die alone in a horrid situation. I will speak to my friend about doing this, and even though he is a Buddhist, perhaps he can find a correlation to my practice.]

PRIESTESS: For your own broken ankles, great things can be done through acupuncture or shiatsu massage to keep the energy flowing through those points. On a psychological level, knowing that you have been pretty able to provide for yourself, you've got a rock-solid foundation. I just see you determining you're not willing to be crippled; you're just not.

And so you can talk to yourself, you can do energy circulating yourself and you can also do physical therapy. Aquatic work would be very helpful to you, strengthening those ankles. I wouldn't accept it if people say you just can't. You might pull a miracle out. You might picture a light switch in your ankle and visualize turning on juice, switching it. You want to be careful and realistic about where you are, but don't accept that as a license.

[So I have to be my own judge and protect and push my own body.]

ME: I feel like as I'm getting older, I have to really focus and enjoy my life. How do you prioritize which things make most difference in the world?

[Again, my confusion about what to value rephrased as a last question.]

PRIESTESS: But I don't know why you think you don't make a difference if you're in Paris—just having fun there. That's a good prescription for you. Have some fun. It refreshes you, and try to let go of berating yourself for not always leading. You can lead. You can make change. You can make a difference, and you also have to recharge your own batteries sometimes and sit back and enjoy the fruits of your labor and let people take care of you. Pamper you a little bit.

Offer up the knowledge and guidance that you have and where someone simply isn't able to listen to you, then you have to maybe step back and be perceptive. See how that affects things and maintain that objective observation, so instead of having to cling to your suggestion, to be able to flow a little bit more. It's something to practice.

[I'm afraid if I flow, I'll flow into basically nothing. This is just a little phase, she tells me. Flow into it, see what it is like. Maybe by sitting back, resting in flow, I'll see more.]

PRIESTESS: Typically we want to make judgments about everything. And the difference is observation as opposed to judgment. Observation based on what is really happening, what is being experienced, rather than theory or projection. Every situation is a new situation. It's important to offer up what

you do know and what your inner guidance tells you. And at the same time, balance that a little, and if it goes the other way, take on that attitude of let's see what that is like.

Take in what happens, realize that even if a person is making a mistake and it becomes very difficult and turbulent, just like in nature there are storms; they are not bad or wrong, they are just storms. You have a lot of grit in you to weather those changes and to then say to somebody at some point, "Well, we went with what you suggested and it's gotten us into difficulty, so that is what I'm observing. This just isn't working." Main thought is to stay in the presence of yourself and to have courage to respond from that.

[To be a leader, I learn I have to have fun, let others lead and make mistakes. Clearly the priestess has pointed to a dangerous but exciting new path of enlightenment for me. We writers want to create everything on the computer screen, but so much of life is interaction, presence and discovery.]

No bell rings, but I feel fulfilled and directed. I thank the priestess, who is smiling, go out and buy a gorgeous rawhide satchel for fifteen dollars in the attached thrift shop.

Later, I talk to my ill friend while he is having chemo. He says he doesn't think he is afraid of having cancer but then admits he has panic dreams, so maybe it's his unconscious trying to reach him. He will reexamine his fear and what he wants to do with his life. He thinks he wants to write and asks me why I write.

I fumble with this question that haunts me and say feebly that I'm seeking to capture my experiences and those of others in Louisiana and pass them on. We argue about my need for immortality and the transience of all, even writing. Then, I realize in the midst of talking: I am most present when writing.

WRITING BRINGS ME JOY.

BIBLIOGRAPHY

Adenle, Adewalé, Nigerian artist and *Congo Square* sculptor. Interview by
 Rory Schmitt in Phoenix, December 13, 2017.

Ambrose, Kala. *Spirits of New Orleans: Voodoo Curses, Vampire Legends, Cities of the
 Dead.* Covington, KY: Clerisy Press, 2012.

Anderson, Stacey. "Voodoo Rebounding New Orleans after Hurricane
 Katrina." *Newsweek*, August 25, 2014. Accessed March 1, 2018. www.
 newsweek.com/2014/09/05/voodoo-rebounding-new-orleans-after-
 hurricane-katrina-266340.html.

"Art in Antiquity 2008: Visual Culture." Brown University. Accessed March
 7, 2018. www.brown.edu/Departments/Joukowsky_Institute/courses/
 artinantiquity/7158.html.

Bodin, Ron. *Voodoo: Past and Present.* Lafayette: University of Southeastern
 Louisiana, 1990.

Branley, Edward. "NOLA History: Voodoo and St. John's Eve." GO NOLA,
 June 16, 2014. Accessed March 1, 2018. gonola.com/things-to-do-in-
 new-orleans/nola-history-voodoo-and-st-johns-eve.

Brydon, Lynne. "Filomena Chioma Steady, Ed. The Black Woman Cross
 Culturally. Schenkman, 1981. Ix 645 Pp. No Price given." *African Studies
 Review* 28, no. 1 (1985): 120–22. doi:10.2307/524576.

Cathedral-Basilica of Saint Louis King of France. Accessed February 15,
 2018. www.stlouiscathedral.org.

Celestin, Oscar "Papa." "Marie Laveau." Accessed February 15, 2018.
 www.allmusic.com/album/marie-laveau-mw0000236563.

Cosentino, Donald. "On Looking at a Vodou Altar." *African Arts* 29, no. 2 (Spring 1996): 67–70.

———. *Sacred Arts of Haitian Vodou.* Los Angeles: Fowler Museum of Cultural History University of California, 1995.

———. "Vodou: A Way of Life." *Material Religion* 5, no. 2 (2015): 250–52.

———. "Vodou in the Age of Mechanical Reproduction." *RES: Anthropology and Aesthetics* 47 (Spring 2005): 231–46.

Coviello, Will. "Ana Dlo Festival and Symposium Is Oct. 17." *Best of New Orleans*, September 22, 2015. Accessed February 15, 2018. www.bestofneworleans.com/blogofneworleans/archives/2015/09/22/anba-dlo-festival-and-symposium-is-oct-17.

Crockett, I'Nasah. "Voodoo Tourism in New Orleans." Academia, 2011. Accessed February 9, 2018. www.academia.edu/6045077/Voodoo_Tourism_in_New_Orleans.

Deren, Maya, and Joseph Campbell. *Divine Horsemen: The Living Gods of Haiti.* New York: McPherson, 2004.

DeShane, Kenneth. "A Morphology for the Pentecostal Experience of Receiving the Baptism in the Holy Spirit." *Western Folklore* 62, no. 4 (2003): 271–91. www.jstor.org/stable/1500320.

Dickinson, Christine. *Aspects of Performativity in New Orleans Voodoo.* George Washington University. N.p.: ProQuest Dissertations Publishing, 2015.

Doninger, Wendy. *Merriam-Webster's Encyclopedia of World Religions.* Springfield, MA: Merriam-Webster, 2000.

Eschner, Kat. "Voodoo Priestess Marie Laveau Created New Orleans' Midsummer Festival." *Smithsonian Magazine,* June 23, 2017. Accessed March 1, 2018. www.smithsonianmag.com/smart-news/voodoo-priestess-marie-laveau-created-new-orleans-midsummer-festival-180963750.

Evans, Janet "Sula Spirit," Vodun-initiated priest. Interview by Rory Schmitt in Phoenix, October 12, 2017.

———. Interview by Rory Schmitt in New Orleans, December 22, 2017.

———. *Spirit of the Orishas.* U.S.: AR Books, 2014.

EWTN Live. Directed by EWTN. Performed by Dr. Ray Guarendi and Fr. Larry Richards. YouTube, November 8, 2017. www.youtube.com/watch?v=FhOBdpBdiMo.

Fandrich, Ina J. "The Birth of New Orleans' Voodoo Queen: A Long-Held Mystery Resolved." *Louisiana History: The Journal of the Louisiana Historical Association,* July 1, 2005. www.jstor.org/stable/4234122.

———. *The Mysterious Voodoo Queen, Marie Laveaux: A Study of Powerful Female Leadership in Nineteenth-Century New Orleans.* New York: Routledge, 2005.

Filan, Kenaz. *The Haitian Vodou Handbook: Protocols for Riding with the LWA*. Rochester, VT: Destiny Books, 2007.

Floori, Marge. "3 Out of 10 Saints Were Psychic." *Weekly World News*, July 24, 2009. weeklyworldnews.com/headlines/10299/3-out-of-10-saints-were-psychic.

Freedman, Samuel G. "Myths Obscure Voodoo, Source of Comfort in Haiti." *New York Times*, February 19, 2010. www.nytimes.com/2010/02/20/world/americas/20religion.html.

Furseth, Inger, and Pål Repstad. *An Introduction to the Sociology of Religion: Classical and Contemporary Perspectives*. 1st ed. London: Routledge, 2016.

Gibson, Campbell. "Library." Population of the 100 Largest Cities and Other Urban Places. June 1, 1998. www.census.gov/library/working-papers/1998/demo/POP-twps0027.html.

Glassman, Sallie Ann, Vodou priestess, Island of Salvation Botanica business owner. Interview by Rory Schmitt in Phoenix, September 28, 2016, and April 7, 2017.

———. Interview by Rory Schmitt in New Orleans, June 2017.

———. Interview by Rosary Hartel O'Neill, January 20, 2018.

———. *Vodou Visions: An Encounter with Divine Mystery*. New York: Villard, 2000.

Griffin, Lea Michelle. *Voodoo in NOLA: The Identity of a City and the Reality of Her Religion*. Pensacola: University of West Florida, 2012.

Haas, Saumya Arya. "What Is Voodoo? Understanding a Misunderstood Religion." Huffington Post, February 25, 2011. Accessed February 14, 2018. www.huffingtonpost.com/saumya-arya-haas/what-is-vodou_b_827947.html.

Hainard, Jacques, and Phillipe Mathez. "Vodou, a Way of Life." *Material Religion* 5, no. 2 (2008): 250.

Hall, Ardencie. *New Orleans Jazz Funerals: Transition to the Ancestors*. New York: New York University, Graduate School of Arts and Science, 1998.

Hall, Gwendolyn Midlo. *Africans in Colonial Louisiana: The Development of Afro-Creole Culture in the Eighteenth Century*. Baton Rouge: Louisiana State University Press, 1995.

Halliwell, Martin. *American Culture in the 1950s*. Edinburgh, Scotland: Edinburgh University Press, 2012.

Haskett, Wendy. "Psychic Fairs Aim for Aura of Fun in Mind Reading." *Los Angeles Times*, August 15, 1987. articles.latimes.com/1987-08-15/news/vw-44_1_psychic-fair.

Hayoun, Massoud. "In Voodoo's Survival, a Tale of Black Resilience." Al Jazeera America, February 25, 2015. america.aljazeera.com/multimedia/2015/2/voodoos-survival-black-history-resilience.html.

Hentschke, Ted. "7 Awesome Voodoo Horror Flicks." Dread Central, February 23, 2016. www.dreadcentral.com/news/152858/7-awesome-voodoo-horror-flicks.

The Historic New Orleans Collection. Accessed February 15, 2018. www.hnoc.org.

Holloway, Joseph E. *Africanisms in American Culture.* Bloomington: Indiana University Press, 2005.

"How Has Visual Culture Been Defined?" *Joss Bailey.* Accessed March 7, 2018. jossbailey.files.wordpress.com/2013/01/defining-visual-culture.pdf.

"Ifa: The Religion of the Yoruba Peoples." Religious Tolerance. Accessed December 4, 2017. www.religioustolerance.org/ifa.htm.

"Interview with Voodoo Tour Guide at the Voodoo Museum in New Orleans." Interview by Rosary Hartel O'Neill, December 5, 2017.

Isaacs, Florence. "Why More Widowers Date, Remarry Than Widows." LegacyConnect. March 18, 2015. connect.legacy.com/profiles/blogs/why-more-widowers-date-remarry-than-widows.

The Island of Salvation Botanica. Accessed February 15, 2018, islandofsalvationbotanica.com.

Jacobs, Claude F., and Andrew Jonathan Kaslow. *The Spiritual Churches of New Orleans: Origins, Beliefs, and Rituals of an African-American Religion.* Knoxville: University of Tennessee Press, 2001.

James, Darius. *That's Blaxploitation!: Roots of the Baadasssss 'tude (Rated X by an All-Whyte Jury).* New York: St. Martin's Griffin, 1995.

Jansson, Bruce S. *The Reluctant Welfare State: Engaging History to Advance Social Work Practice in Contemporary Society.* Australia: Cengage Learning, 2015.

Jones, Jacqueline. *Labor of Love, Labor of Sorrow: Black Women, Work and the Family from Slavery to the Present.* New York: Basic Books, 2010.

K., P. "Interview with Practitioner of Voodoo in Lafayette, Louisiana." Interview by Rosary Hartel O'Neill, February 26, 2017.

Katz, Jonathan. "Explore the Timeless World of Vodou Deep within the Caves of Haiti." *Smithsonian Magazine,* July 2017. Accessed February 18, 2018. www.smithsonianmag.com/arts-culture/explore-timeless-world-vodou-haiti-180963673.

Kelley, Brandi, Vodou priestess, Voodoo Authentica business owner. Interview by Rory Schmitt in New Orleans, June 5, 2017.

Kelly, Debra. "10 Things You Didn't Know About Voodoo." Listverse, December 11, 2013. listverse.com/2013/12/11/10-things-you-didnt-know-about-voodoo.

Klassen, Sherri. "Widows and Widowers." Encyclopedia of European Social History, 2001. www.encyclopedia.com/international/encyclopedias-almanacs-transcripts-and-maps/widows-and-widowers.

Kolb, Carolyn. "Voodoo to Do: A Spirited Look at Its Meaning and Practitioners." *New Orleans Magazine.* Accessed March 1, 2018. www. myneworleans.com/New-Orleans-Magazine/June-2009/Voodoo-to-do.

Laski, Marghanita. *Ecstasy: A Study of Some Secular and Religious Experiences.* Santa Barbara, CA: Greenwood Publishing Group, 1968.

Laurence, Alison, and Sarah Waits. "Mosquitoes and Yellow Fever: Stop 3 of 4 in the Animals in the French Quarter Tour.: New Orleans Historical. Accessed November 15, 2017. neworleanshistorical.org/items/show/132?tour=12&index=2.

Lawless, Elaine J. "'The Night I Got the Holy Ghost...': Holy Ghost Narratives and the Pentecostal Conversion Process." *Western Folklore* 47, no. 1 (1988): 1–19. doi:10.2307/1500052.

Leavitt, Judith Walzer. *Brought to Bed: Childbearing in America, 1750 to 1950.* New York: Oxford University Press, 2016.

Liddell, Henry George, Robert Scott, Henry Stuart Jones and Roderick McKenzie. *Greek-English Lexicon.* Oxford, UK: Clarendon Press, 2006.

Litwin, Sharon. "Culture Watch: A Return to Congo Square." NOLA.com, May 31, 2011. www.nola.com/nolavie/index.ssf/2011/05/culture_watch_a_return_to_cong.html.

Locke, Ralph G., and Edward F. Kelly. "A Preliminary Model for the Cross-Cultural Analysis of Altered States of Consciousness." *Ethos: Journal of the Society for Psychological Anthropology* 13, no. 1 (1985): 3–55.

Long, Carolyn Morrow. "Famille de Vve Paris née Laveau: The Tomb of Marie Laveau in St. Louis Cemetery No. 1." Know Louisiana, 2015. Accessed February 15, 2018. www.knowlouisiana.org/40870-2.

———. "Marie Laveau." In *knowlouisiana.org Encyclopedia of Louisiana,* edited by David Johnson. Louisiana Endowment for the Humanities, 2010–. Article published October 3, 2017. www.knowlouisiana.org/entry/marie-laveau-2.

———. *A New Orleans Voudou Priestess: The Legend and Reality of Marie Laveau.* Gainesville: University Press of Florida, 2007.

———. "Perceptions of New Orleans Voodoo: Sin, Fraud, Entertainment, and Religion." *Nova Religio: The Journal of Alternative and Emergent Religions* 6, no. 1 (2002): 86–101.

Lowenthal, Ira P. "Ritual Performance and Religious Experience: A Service for the Gods in Southern Haiti." *Journal of Anthropological Research* 34, no. 3 (Autumn 1978): 392–414. www.journals.uchicago.edu/doi/pdfplus/10.1086/jar.34.3.3629785.

BIBLIOGRAPHY

"Lyrics, Marie Le Veau." Musix Match. Accessed February 15, 2018. www.musixmatch.com/lyrics/Oscar-Papa-Celestin-feat-The-Original-Tuxedo-Jazz-Band/Marie-Le-Veau.

MacCallum-Whitcomb, Susan, and Julie Ann Tharp. *This Giving Birth: Pregnancy and Childbirth in American Women's Writing*. Bowling Green, OH: Bowling Green State University Popular Press, 2000.

Managan, Kathe. "The Term 'Creole' in Louisiana: An Introduction." Lameca.org, October 18, 2015.

Martinié, L., and S. Glassman. *New Orleans Vodou Tarot*. Rochester, VT: Destiny Books, 1992.

Mayo, David. "I Married a Voodoo Altar." *African Arts* (Spring 1996): 70.

McCay, J.J. "'Chicken Man; Prince Ke'eyama, the One True King of New Orleans Voodoo." Haunted America Tours, April 22, 2015. www.hauntedamericatours.com/newreportsarchives/Chickenmanvoodoo.php.

Michels, Barry, and Phil Stutz. *Coming Alive: 4 Tools to Defeat Your Inner Enemy, Ignite Creative Expression & Unleash Your Soul's Potential*. New York: Spiegel & Grau, 2017.

Mills, Gary, and Elizabeth Shown Mills. *The Forgotten People: Cane River's Creoles of Color*. Baton Rouge: Louisiana State University Press, 2013.

Moise, Houngan Sen, Vodou priest, Crescent City Conjure business owner. Interview by Rory Schmitt in Phoenix, October 9, 2017.

Monteverde, Danny. "Healing Center Open House Offers Hope for St. Claude Revival." *Times-Picayune*, June 13, 2009. Accessed February 15, 2018. www.nola.com/news/index.ssf/2009/06/healing_center_open_house_offe.html.

Moore, Thomas. *A Religion of One's Own: A Guide to Personal Spirituality in a Secular World*. Garden City, NY: Avery Publishing, 2014.

Morrison, Betty. *A Guide to Voodoo in New Orleans, 1820–1940*. Gretna, LA: Her Pub. Co., 1977.

Mulira, Jessie Gaston. "The Case of Voodoo in NOLA." In *Africanisms in American Culture*, edited by Joseph Holloway. Bloomington: Indiana University Press, 1991.

Murphy, Michael. *Fear Dat New Orleans: A Guide to the Voodoo, Vampires, Graveyards and Ghosts of the Crescent City*. New York: Countryman Press, 2015.

New Orleans Healing Center: About Us. Accessed February 15, 2018. www.neworleanshealingcenter.org/about-us.

The New Orleans Historic Voodoo Museum. Accessed February 15, 2018. www.voodoomuseum.com.

New Orleans Pharmacy Museum. Accessed February 15, 2018. www.pharmacymuseum.org.

New York State's Reptile and Amphibian Laws: An Overview. The New York Turtle and Tortoise Society. Accessed June 27, 2017. www.nytts.org/nytts/DEC_regs.htm.

Nickell, Joe. "Voodoo in New Orleans." Editorial. *Skeptical Inquirer*, January/February 2002. www.csicop.org/si/show/voodoo_in_new_orleans.

O'Brien, Rachelle, Vodou ceremony guest. Interview by Rory Schmitt in New Orleans, June 2017.

"Oshun." *Encyclopedia Britannica*. Accessed March 1, 2018. www.britannica.com/topic/Oshun.

Painter, Sally. "Understanding Voodoo Possession." LoveToKnow. Accessed December 15, 2017. paranormal.lovetoknow.com/about-paranormal/understanding-voodoo-possession.

"Petwo/Kongo altar. *"African Arts* (Spring 1996): 69.

Pierce, Catherine. "The Difference Between Hoodoo and Voodoo." KnowledgeNuts, December 26, 2013. knowledgenuts.com/2013/12/26/the-difference-between-hoodoo-and-voodoo.

Pinn, Anthony B. *Varieties of African-American Religious Experience*. Minneapolis: Fortress Press, 1998.

Preston, Samuel H., and Michael R. Haines. *Fatal Years: Child Mortality in Late Nineteenth-Century America*. Princeton, NJ: Princeton University Press, 2014.

Priestess Miriam. "Interview with a Voodoo Priestess." Interview by author, February 3, 2018.

Pustanio, A. "Hurricane Protection Ritual." Haunted New Orleans Tours. Accessed March 1, 2018. www.hauntedneworleanstours.com/voodoo/vodouhurricane.

Quarles, Benjamin. *The Negro in the Making of America*. 3rd ed. New York: Simon & Schuster, 1996.

"Rada altar." *African Arts* (Spring 1996): 68.

Raitano, M. "Powerful Priestesses: A Look at Equality in Leadership in Vodou." University of Florida. Accessed May 22, 2017. ufdcimages.uflib.ufl.edu/AA/00/01/50/46/00001/Vodou%20Whole%202012_Secured.pdf.

Ravitz, Jessica. "Unveiling New Orleans Voodoo." *Salt Lake Tribune*, November 24, 2008. archive.sltrib.com/story.php?ref=%2Fci_10798634.

Reuber, Alexandra. "Voodoo Dolls, Charms, and Spells in the Classroom: Teaching, Screening, and Deconstructing the Misrepresentation of the African Religion." *Contemporary Issues in Education Research* 4, no. 8 (2011): 7–18.

Rice, John R. *Speaking in Tongues*. Murfreesboro, TN: Sword of the Lord Publishers, 1971.

Richard, Zachary. "Colinda Lyrics." LyricsMode. Accessed December 24, 2017. www.lyricsmode.com/lyrics/z/zachary_richard/colinda.html#!.

Roberts, Kodi. *Voodoo and Power: The Politics of Religion in New Orleans: 1881–1940*. Baton Rouge: Louisiana State University Press, 2015.

Ronen, D., S. Adotevi and R. Law. "Benin Republic, Africa." *The Encyclopedia Britannica*, September 13, 2017. Accessed December 4, 2017. www.britannica.com/place/Benin#ref516982.

The Sacred Music Festival. Accessed February 15, 2018. www.neworleanssacredmusicfestival.org.

"Safer, Healthier People." Morbidity and Mortality Weekly Report, October 1, 1999 / 48(38);849-858. Centers for Disease Control and Prevention.

Schmitt, R. *Art Museum Educators and Curators: An Examination of Art Interpretation Priorities and Teachers' Identities*. Arizona State University. N.p., ProQuest Dissertations Publishing, 2014.

Scott, Nate. "Interview with a Voodoo Man." Interview by Rosary Hartel O'Neill, December 3, 2017.

Shabazz, Kwame Zulu. "Snake Gods in the Vodoun ('Voodoo') Religion." Thoughts of a Ghetto Intellectual, June 26, 2011. imperfect-black.blogspot.com/2011/06/snake-gods-in-vodoun-voodoo-religion.html.

Shephard, Sherry P. "Women Finding Their Place as Church Leaders." Shreveporttimes.com, March 28, 2015. www.shreveporttimes.com/story/news/local/2015/03/28/women-finding-place-church-leaders/70591094.

Smith, G.S. "Marie Catherine Laveau: Voodoo Queen of New Orleans (September 10, 1801–June 15, 1881)." StrangeHistory.org, March 5, 2012. www.strangehistory.org/cms/index.php/archive21/55-marie-catherine-laveau-voodoo-queen-of-new-orleans-september-10-1801-june-15-1881.

Snyder, Mark, Elizabeth Decker Tanke and Ellen Berscheid. "Social Perception and Interpersonal Behavior: On the Self-Fulfilling Nature of Social Stereotypes." *Journal of Personality and Social Psychology* 35, no. 9 (1977): 655–66. doi:10.1.1.335.3131.

"Species of Lizards and Snakes Found in New York." New York State Department of Environmental Conservation. Accessed June 27, 2017. www.dec.ny.gov/animals/7483.html.

Stanley, Tiffany. "The Disappearance of a Distinctively Black Way to Mourn." *Atlantic*, January 26, 2016. www.theatlantic.com/business/archive/2016/01/black-funeral-homes-mourning/426807.

Star, Riley. *Voodoo: History, Beliefs, Elements, Strains or Schools, Practices, Myths and Facts: An Introductory Guide.* NV: NRB, 2016.

St. John's Eve ceremony. Faubourg St. John, June 21, 2016. Accessed March 1, 2018. fsjna.org/2016/06/st-johns-eve-ceremony.

Stokstad, Marilyn. *Art History.* New York: Harry N. Abrams, Inc., 1995.

"Stop Religious Persecutions of Voodoo in Haiti; An Inspiration to Art." *New York Times,* May 25, 1986. www.nytimes.com/1986/05/25/opinion/l-stop-religious-persecutions-of-voodoo-in-haiti-an-inspiration-to-art-423886.html.

Tailor, Hideaki. "First Woman Priest." *Weekly World News,* February 28, 2017. weeklyworldnews.com/headlines/56040/first-woman-priest.

Tallant, Robert. *Voodoo in New Orleans.* Gretna, LA: Pelican Publishing, 1983.

Tannenbaum, Rebecca Jo. *Health and Wellness in Colonial America.* Vol. 1. Denver: Greenwood, 2012.

Teish, Luisah. *Jambalaya: The Natural Woman's Book of Personal Charms and Practical Rituals.* San Francisco: HarperOne, 1988.

Thomas, Eugene. "Interview with a Former Babalawo, a West African Priest in New Orleans African-American Community." Interview by Rosary Hartel O'Neill. February 6, 2018.

Thomas, Irma. "I Done Got Over/ Iko Iko/ Hey Pockey Way." *Music Cares Hurricane Relief* album, 2005.

Torres-Tama, Jose, New Orleans artist. Interview by Rory Schmitt in Phoenix, October 10, 2017.

Toth, Emily. *Unveiling Kate Chopin.* 50263rd ed. Jackson: University Press of Mississippi, 1999.

Tsutsumi, Patricia. "Interview with Patricia Tsutsumi, Cranial Massage Therapist and Healer." Interview by Rosary Hartel O'Neill, February 27, 2017.

Tucker, A. "The New Orleans Historic Voodoo Museum." *Smithsonian Magazine,* June 2011. Accessed February 15, 2018. www.smithsonianmag.com/arts-culture/the-new-orleans-historic-voodoo-museum-160505840.

Turner, Richard Brent. "The Haiti–New Orleans Vodou Connection: Zora Neale Huston as Initiate Observer." In *Jazz Religion, the Second Line, and Black New Orleans.* Bloomington: Indiana University Press, 2009.

———. *Jazz Religion, the Second Line, and Black New Orleans.* Bloomington: Indiana University Press, 2009.

Tyler, Pamela. *New Orleans Women and the Poydras Home: More Durable than Marble.* Baton Rouge: Louisiana State University Press, 2016.

"Visual Culture." Encyclopedia. Accessed March 7, 2018. www.encyclopedia.com/history/dictionaries-thesauruses-pictures-and-press-releases/visual-culture.

The Voodoo Spiritual Temple. Accessed February 15, 2018. www.voodoospiritualtemple.org.

Ward, Martha, anthropologist, author of *Voodoo Queen: The Spirited Lives of Marie Laveau*. Interview by Rory Schmitt in Phoenix, March 31, 2017.

———. Interview by Rory Schmitt in New Orleans, June 2017.

———. "Interview with Martha Ward." Interview by Rosary Harzinski, January 27, 2018.

———. *Voodoo Queen: The Spirited Lives of Marie Laveau*. Jackson: University Press of Mississippi, 2004.

Watland, Geoff. "The International Shrine of Marie Laveau in New Orleans." YouTube. Accessed February 15, 2018. www.youtube.com/watch?v=Lww66HyK-XE.

Wehmeyer, Stephen. "Interview with Dr. Stephen Wehmeyer, Afro-Atlantic Scholar." Interview by Rory Schmitt in Phoenix, AZ, February 6, 2018.

"Where Voodoo Meets Catholicism in New Orleans Hurricane Turning Ceremony." *Atom Bash* 28 (July 25, 2015). Accessed March 1, 2018. atombash.com/where-voodoo-meets-catholicism-in-new-orleans-hurricane-turning-ceremony-xxviii.

"Women and the Law." Women, Enterprise and Society. 2010. www.library.hbs.edu/hc/wes/collections/women_law.

Wooten, Nicholas. "St. John's Eve Head-Washing June 23 Honors Voodoo and Its Queen, Marie Laveau." *Times-Picayune*, June 22, 2015. Accessed March 1, 2018. www.nola.com/festivals/index.ssf/2015/06/voodoo_voudou_stjohns_eve.html.

Wyatt, Olivia. "Interview with Olivia Wyatt, Voodooist." Interview by Rosary Hartel O'Neill, March 12, 2017.

"Yoruba." *Countries and their Cultures*. Accessed December 4, 2017. www.everyculture.com/wc/Mauritania-to-Nigeria/Yoruba.html.

"Yoruba People." *The Encyclopedia Britannica*. Accessed December 4, 2017. www.britannica.com/topic/Yoruba.

INDEX

ABOUT THE AUTHORS

ROSARY HARTEL O'NEILL lives in New Orleans and New York City with her husband, Robert Harzinski. She is the author of twenty-five plays (eighteen published by Samuel French, Inc.) and three books of nonfiction. The fourth edition of her text *The Actor's Checklist* is used in schools nationwide. Her book *New Orleans Carnival Krewes: The History, Spirit and Secrets of Mardi Gras* was published by The History Press in 2014.

A senior Fulbright drama specialist, she has received six Fulbrights, most recently to Paris, where her play *Degas in New Orleans* was performed at the Sorbonne University and the Global Center of Columbia University. Other awards include residencies at the Tyrone Guthrie Centre in Ireland, the American Academy in Rome and the Irish Cultural Center and Cartoucherie Theatre in Paris. In 2015, Rosary was a keynote speaker on Carnival in Cologne, Germany.

In New York City, she is an active member of the Actors Studio, the Players Club and the National Arts Club. In New Orleans, Louisiana, she is professor emeritus of drama and speech at Loyola University and a member of Louisiana Women in Film and Television. She founded Southern Rep Theatre, the premier professional theatre in New Orleans.

RORY O'NEILL SCHMITT, PhD, MPS, ATR-BC, is an author, photographer and professor.

Rory was raised in New Orleans, Louisiana, and was always fascinated with art. Upon graduating from St. Mary's Dominican High School, she

moved to New York, where she attended Fordham University and earned her bachelor's degree in art history and studio art. Rory has had an authentic interest in art and understanding peoples of diverse art worlds. She has studied in China and Great Britain and completed volunteer work in Guyana and Romania.

Interested in exploring how art leads to healing, she pursued her master's degree in art therapy from the School of Visual Arts in New York City. As a board-certified art therapist, she has led groups and individual sessions with adolescents and adults in rehabilitation programs in San Diego and has also directed adjunctive therapists.

Exploration of how individuals further find meaning through art, as well as teach others how to interpret art, led her to earn her PhD in curriculum and instruction studies with a concentration in art education at Arizona State University in Tempe. Dissertation research included a focus on education and curation at the Museum of Modern Art, the Metropolitan Museum of Art and the Heard Museum.

Fascinated by art forms in many realms, she has gained professional experiences over the years at museums and galleries in New York, California and Arizona, such as the International Center for Photography, Cristinerose Gallery, Visual Arts Gallery, the San Diego Chinese Historical Society and Museum and the Arizona State University Art Museum.

Additionally, she finds joy in teaching and served as lecturer at Arizona State University's University College. She currently works at the University of Southern California's Bovard College, where she coaches and supports expert faculty.

Rory's passion is in her writing, photography and research. Her work is dedicated to understanding individuals' life stories, culture, spirituality and art. In February 2016, Rory published her first book with The History Press, titled *Navajo and Hopi Art in Arizona: Continuing Traditions*. She is thrilled to be publishing her second book with The History Press/Arcadia Publishing on her hometown of New Orleans.

Visit us at
www.historypress.com

CPSIA information can be obtained
at www.ICGtesting.com
Printed in the USA
LVHW010222230723
753131LV00005B/220

9 781540 237255